RETROMANIA

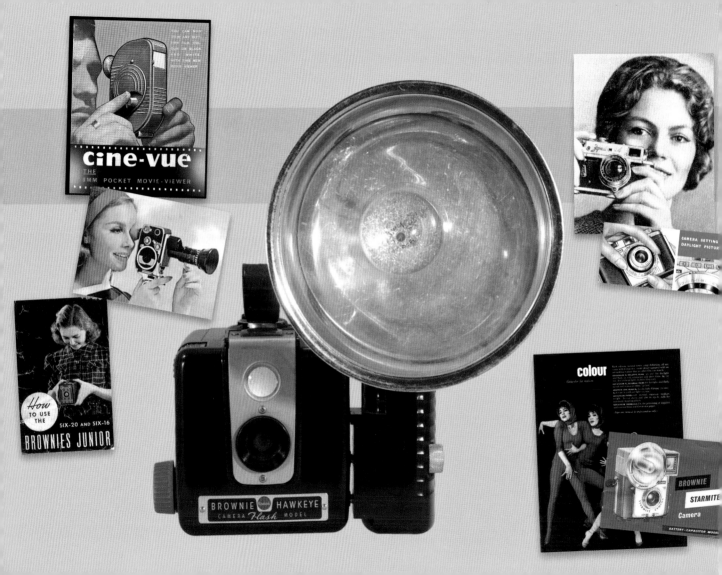

RETROMANIA

······ *The* **FUNKIEST CAMERAS** *of* **PHOTOGRAPHY'S GOLDEN AGE** ······

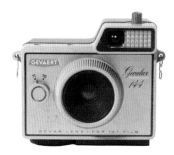

LAWRENCE HARVEY

ILEX

First published in the UK in 2012 by
ILEX
210 High Street
Lewes
East Sussex BN7 2NS
www.ilex-press.com

Copyright © 2012 The Ilex Press Ltd.
All rights reserved

Publisher: Alastair Campbell
Associate Publisher: Adam Juniper
Creative Director: James Hollywell
Managing Editor: Natalia Price-Cabrera
Editor: Tara Gallagher
Specialist Editor: Frank Gallagher
Senior Designer: Ginny Zeal
Designer: Jon Allan
Colour Origination: Ivy Press Reprographics

British Library Cataloguing-in-Publication Data
A catalogue record for this book is available
from the British Library

ISBN: 978-1-78157-001-2

CONTENTS

INTRODUCTION

Photography has been around for more than 170 years and its official birth coincided with Fox Talbot's paper, *Account of the Art of the Photogenic Drawing*, presented to the Royal Society in 1839. Now, as this book goes into production in the second decade of the twenty-first century, it's a given that just about anyone on our planet can take a photograph, easily and instantly, thanks to the combination of digital and mobile-phone technology.

But step back in time to the beginning of the previous century and you'll see a completely different scenario. Picture taking, formerly the domain of the wealthy, often scientific, enthusiast, began to enter the public consciousness as people became aware of its potential. As the century unfolded, simple cameras that were easy to understand and operate enabled Everyman to record his daily life, for himself, in all its gritty detail.

Many companies were established to manufacture cameras, initially in Britain, Japan, Germany, France, the USA, and later in Russia and beyond, and optical manufacturers, such as Voigtländer in Braunschweig also diversified into photography. The re-emergence of LOMO cameras as a popular film-camera option in the late 1990s is an indication that film cameras still had their place amongst serious photographers beyond the advent of the digital age. Added to this, a large and growing number of dedicated amateur photographers worldwide have supported the use of film in top-quality cameras so that, today, brands such as Fuji and Ilford continue to successfully sell film and photographic darkroom wet-processed paper.

Thanks to the ingenuity of truly visionary individuals and companies, mass production made photography accessible to millions, and through all manner of interesting devices, turned it into the global phenomenon that it is today—it has been estimated that 16 billion images are taken every single day.

This book touches just the very tip of the iceberg (hopefully, not like the Titanic) of the phenomenon known as "film-based" photography, before it morphed into the digital colossus that it is now. Within this book, 77 photographic devices are examined and placed on a time line, complete with relevant advertising and packaging, giving us a fascinating glimpse into a forgotten world.

FILM TYPES & FORMATS

The cameras selected for this book used a total of 15 different classifications of film to produce 22 different dimensional formats.

Most standard classifications of roll film were first introduced by Eastman Kodak, who first marketed flexible photographic film in 1885. The longest-lived and still popular type of roll film (120) was first introduced by Kodak in 1901 and is still made by Fuji and Harman (Ilford).

127 size film appeared in 1912 with the Vest Pocket Kodak (VPK), which became known as "the soldier's camera" during the First World War. Kodak made 127 film until 1995 and a manufacturer in Croatia is still manufacturing 127. Then 620 film—which had the same dimensions as 120, but on a different spool—was introduced by Kodak in 1932 to fit a large number of successive Kodak 620 cameras and to monopolize film sales for those cameras. Other key roll film types were 116 and 616, 129, Bantam 828, and 135 for 35mm film without backing paper in cassettes, but there were many more.

THE FILM TYPES

No.	Type
01.	120
02.	127
03.	E10
04.	Super Lumichrome
05.	620
06.	8mm Cine
07.	35mm
08.	Polaroid 12 × 10
09.	16mm Cine
10.	126
11.	Polaroid 8 × 6
12.	110
13.	Disc
14.	Polaroid 8 × 8
15.	APS *Advanced Photo System*

THE FORMATS

All film except for the Polaroid (prints).

No.	Format
01.	6 × 9cm
02.	6 × 6cm
03.	6 × 4.5cm
04.	6 × 4cm
05.	4 × 4cm
06.	4 × 3cm
07.	3 × 3cm
08.	4 × 2.8cm
09.	12 × 10cm (Polaroid)
10.	8 × 8cm (Polaroid)
11.	8 × 6cm (Polaroid)
12.	35mm Roll film
13.	35mm Sprocketed
14.	4.5 × 3.3mm
15.	10 × 14mm
16.	28 × 28mm
17.	24 × 18mm
18.	13 × 17mm
19.	10.5 × 8mm
20.	30 × 17mm *Advanced Photo System*
21.	25 × 17mm *Advanced Photo System*
22.	30 × 9.5mm *Advanced Photo System*

35mm roll film.

126 film (Kodak Instamatic) 28 × 28mm.

35mm with sprockets—actually 36mm × 24mm. The Kodak Bantam and Bantam Colorsnap series of cameras used 828 roll film, which was unperforated 35mm film supplied as a roll film with backing paper, giving a 24mm × 36mm image, like that of perforated full-frame 35mm.

120 film gave 6 × 6cm (shown left), 6 × 9cm, or 6 × 4.5cm. 127 film gave 4 × 6cm, 4 × 4cm, 4 × 3cm ("half frame"), or 3 × 3cm.

Chapter 1

1900–1949

By the time 1900 arrived, photography had experienced 60 years of camera production that had generated specimens best described to the untrained professional as bizarre, complicated, bulky, fiddly, and unfathomable. What chance had the world of coming to terms with these hefty constructions that required the use of tripods, knowledge of toxic chemistry, and university qualifications in mathematics and patience?

Luckily, forward-thinking manufacturers seemed to grasp the notion of smaller, lighter products that were easier to use, and that these were vital elements if they wanted to profit from the everyday man or woman. Equally important was the idea that new camera buyers should not be encumbered with the mysteries of film developing and printing. Enter George Eastman and other pioneers...

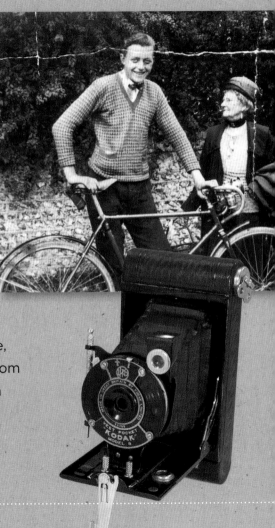

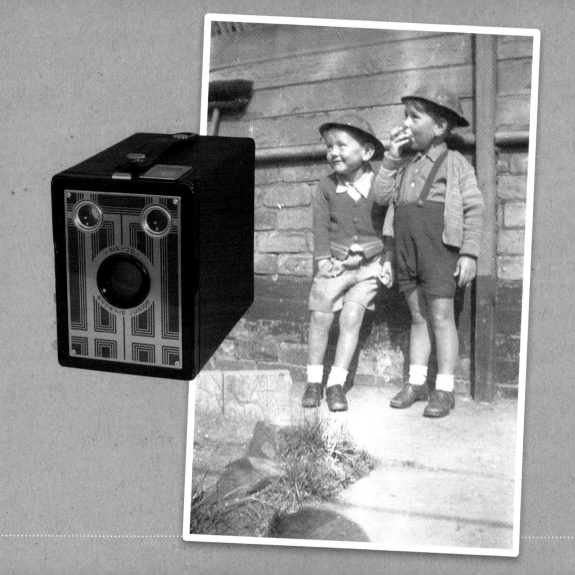

Kodak
NO.2 FOLDING POCKET BROWNIE B 1907

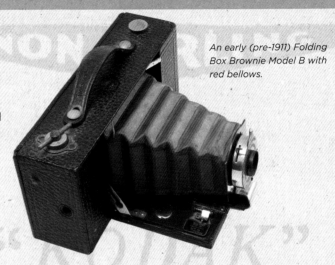

An early (pre-1911) Folding Box Brownie Model B with red bellows.

The official name of this camera was the "Folding Box Brownie Model B" and it was manufactured between 1907 and 1915. This version with the red bellows was pre-1911 (later models had black bellows) and comprised a sturdy wooden box and brass lens unit with imitation leather covering. This was a reliable, basic camera for the amateur that used the 120 film format and—as it proudly proclaimed in the Kodak catalog of the time—gave "12 exposures without reloading."

In the excellent work *The Story of Kodak* by Douglas Collins, the author hits the nail on the head when he writes: "Once the man in the street discovered the absolutely compelling idea of no-fuss, no-fault picture taking, the Kodak camera began selling in numbers unmatched in the history of photography." 100 years later it was still doing just that.

Whenever you made a purchase from Kodak, you bought into a whole photography philosophy—the film, the camera, even membership to its Kodak Correspondence College.

George Eastman set up his company in 1888 and pioneered the famous Kodak slogan "You press the button, we do the rest." It should be pointed out that this referred only to the very first Kodak box cameras, which were supplied pre-loaded with film in the factory, produced circular images and were returned complete via the mail by the owner for the film to be processed and printed by Kodak, who then reloaded the camera and sent it back with the pictures. Once

Dimensions:	Country:	Lens:
H **3.55in / 90mm**	**USA**	**Meniscus**
W **6.7in / 170mm**		Film:
L **5.1in / 130mm**		**120**

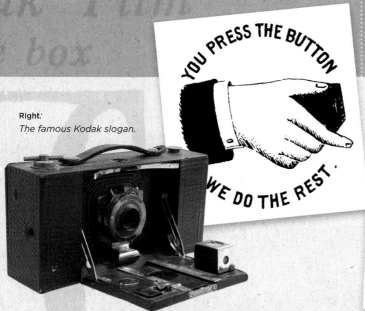

Right:
The famous Kodak slogan.

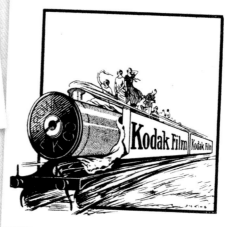

paper-backed roll films were available in shops (the 120 roll film was introduced by Kodak in 1901), independent developing and printing services, usually at or through pharmacies, took over the processing role, and many amateur photographers did the processing and printing themselves.

This sample is in such good condition because, tragically, the owner bought it before going off to the First World War, and never returned.

Left:
With the lens and shutter retracted into the body of the camera, the viewfinder can be seen on the baseboard.

Around 175,000 units of this model were made, and according to a Customer Service pamphlet released in 1999, had a list price of $5 (equivalent to about six day's wages for the average worker in 1907).

Kodak
VEST POCKET MODEL B 1925

So called because it would fit into a vest pocket, the Model B was one of a series of best-selling Kodak cameras made during the early part of the twentieth century. Produced between 1925 and 1934 in the UK, it used the new, smaller 127 film format and had an "autographic" feature, whereby the photographer could scratch data onto the backing paper of the film with the supplied stylus—seen here to the left of the lens—which would then imprint itself permanently on the negative.

The Kodak company bought the rights to the "autographic" for a massive $300,000 from its designer Mr Henry Gaisman in 1914. The sum paid illustrates what a heavy-hitter Kodak had already become, especially when you consider that the whole camera sold for $7 (or for £1.5s.0d in the UK, when the average weekly wage was about £1.10s.0d).

Ironically, very few films turn up with data imprinting, so perhaps the novelty was not as popular as the camera, although its unique selling point was definitely its size, as marketed in the *British Journal of Photography* of 1929: "It is so small and light that it really will go comfortably into a waistcoat pocket— just like a cigarette case—or into a lady's wrist bag."

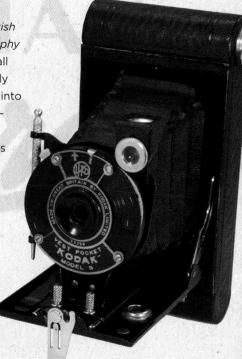

The mid-1920s Vest Pocket Kodak Model B was easier to use than the original of 1912. Squeezing together the two knurled grips below the lens standard, the bellows retracted and the camera folded.

Dimensions:	Country:	Lens:
H 4.7in / 120mm	**UK**	**Rapid Rectilinear**
W 2.5in / 62mm		Film:
L 3.9in / 100mm		**127**

Vest Pocket
Kodak
Model B

Auto Race up Pikes Peak. f.4.5 1/200 sec.

Horse Show, Rochester, N.Y. 9/7/27

Edward, Vivian and John. 11/24/27

Niagara Falls, N.Y. f.16 1/100 sec.

8 point Adirondack Deer. E.G.C. f.11 1/2

Watkins Glen, N.Y. f.16 2 secs. 8/2

Autographic Records.

The Method

FIG. VI

Pushing back the

Above (Left to Right):
The Vest Pocket Kodak Model B was excellent value for working families. Examples of information that could be inscribed on the autographic film with the stylus were illustrated in the manual.

Right: *Advertisement from the* British Journal of Photography *almanac, 1929.*

Box "Brownies"
THE SIMPLEST CAMERAS

Children and beginners find the Box "Brownie" very easy to use. It is the simplest form of camera, yet because of its excellent design it makes first rate pictures. "Kodak" workmanship and durability. Good quality lenses and Time and Instantaneous Shutter.

Prices :

				£	s.	d.
No. 0 "Brownie" for pictures	2¼ × 1¾ ins.	0	10	6
No. 2	"	3¼ × 2¼	..	0	12	6
No. 2A	"	4¼ × 2½	..	0	17	6
No. 2C	"	4¼ × 2⅝	..	1	5	0
No. 3	"	4¼ × 3¼	..	1	2	6

Vest Pocket "Kodak"
MODEL B

Handiness is the outstanding feature of the Vest Pocket "Kodak." It is so small and light that it really will go comfortably into a waistcoat pocket, just like a cigarette case, or into a lady's wrist-bag.

The Model B is "fixed-focus" and is, therefore, always ready for instant use.

The equipment—Meniscus lens, Rotary shutter for Time and Instantaneous exposures, four diaphragm apertures, brilliant reversible finder, tripod sockets and Autographic device (an exclusive "Kodak" feature).

Strongly made in leatherette-covered metal.

The Vest Pocket "Kodak" Model B represents the utmost possible value for money.

Price : £1 5 0

Kodak Ltd., Kingsway, London, W.C.2

Ensign-Houghton
ALL-DISTANCE 20 BOX CAMERA 1927

This robust all-metal box camera was built to survive and resembled a piece of military hardware, particularly with the words "Use E20 Ensign Film" emblazoned on the inside in stencilled lettering.

The camera was advertised as having an "All-Distance Optical System"—actually, a combination of a sliding aperture plate to stop the lens down to about *f*/16 to give greater depth of field, and a facility to pull the lens out on a tube to a close-focus position for portraits. By the time of the All-Distance 20 Box production (1927) Ensign already had a history going back almost a century to the 1830s when, under its original name of Houghton, the company had been involved in producing glass optics for lenses.

Ensign became the brand name for the company's film products that were manufactured from 1903 onwards. It was known for its interesting, quirky illustration style (the one shown opposite from 1930 perhaps demonstrates some water-resistant capabilities). Like most box cameras, the Ensign All-Distance 20 was relatively cheap (£0.13s.6d, or $1.06 in 1932—about two day's pay, based on the UK average weekly wage) and reliable and simple to use, producing excellent results with eight 6 × 9 shots per roll.

To help the photographer compose his subject there was a pull-out wire frame at the front of the camera (a "direct-vision" viewfinder), and another smaller one at the back to squint through, giving more accurate framing.

The box cameras were very popular with the public and sold in huge numbers for decades right up to the late 1950s.

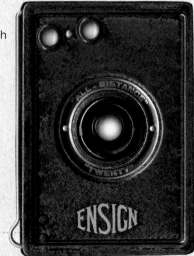

Many of these box cameras were identified by the Ensign film number they used, for example, "Ensign 29" which used E29 film.

Dimensions:	Country:	Lens:
H 3.9in / 100mm	UK	**All-distance fixed focus**
W 2.75in / 70mm		Film:
L 4.75in /120mm		**120**

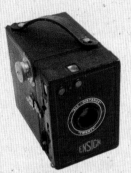

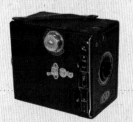

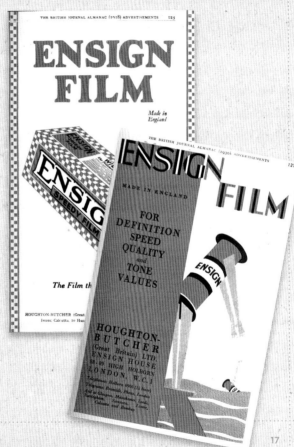

Above: *Houghton-Butcher, later Ensign (from 1930) marketed a broad range of roll films, and actually initiated some sizes, such as its E1 and E2 sizes for Ensignette cameras.*

Top Right: *Advertisement from* The British Journal of Photography *almanac, 1930.*

Right: *Ensign had its own numbering for popular film sizes—E20, shown here, was its number for 120 film, giving eight exposures of 2 1/4" × 3 1/4".*

Contessa-Nettel
QUARTER PLATE FOLDING CAMERA 1928

Working out of Stuttgart, Dr. August Nagel began his camera-design business more than a century ago in 1908, becoming Contessa Camerawerke in 1909. A decade later, he bought Nettel, and by 1926, had become amalgamated, along with several other manufacturers that year, into the industry giant Zeiss Ikon (see pages 26–27).

An agent for the distribution of Nettel merchandise, Sands Hunter & Co based in The Strand, London, duly noted in its 1927 advert that this was "Undoubtedly one of the neatest and most compact quarter-plate cameras on the market." A quality piece of German engineering (of course), the Contessa was not the cheapest at £6.12s.6d (approx. $10.39)—the average weekly wage being about £1.12s.0d (approx. $2.51) at the time—but it was fitted with the quality Zeiss lens, which meant superb images.

The camera compressed down to fit a leather-covered metal case that measured 11.5 × 15 × 5cm—quite compact for a plate camera—and had a swivel viewer that allowed for landscape or portrait viewing. The reputation of Dr. Nagel was such that he was invited to join the Kodak empire in 1931 to develop the Retina range of 35mm cameras. This became Kodak AG in Germany.

A camera-nut himself, my father owned a Contessa, bought in Austria in the 1950s, that weathered at least 50 years of use—not a bad return on the original investment.

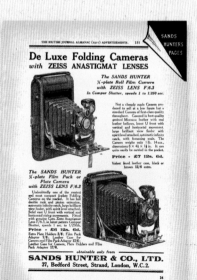

An advertisement from the British Journal of Photography *almanac, 1927.*

Dimensions:	Country:	Lens:
H 5.9in / 150mm	Germany	Sonnar Anastigmat 1:4.5 ƒ/13.5
W 4.5in / 115mm		Film:
L 7.6in / 192mm		120

1900-1949

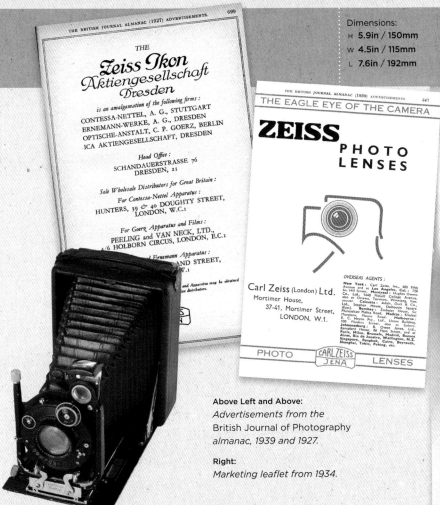

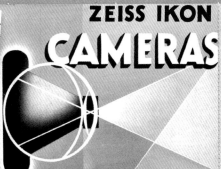

Above Left and Above:
Advertisements from the
British Journal of Photography
almanac, 1939 and 1927.

Right:
Marketing leaflet from 1934.

Kodak
SIX-20 BROWNIE JUNIOR 1934

Kodak used the generic term "Brownie" for a huge variety of cameras throughout the twentieth century. Like so many of Mr. Eastman's products, the Brownies were intended to provide the man in the street with an affordable snap-shooter. According to the manual, snapshots are "light pictures."

The Brownie name is attributed to Frank Brownell, whose simple designs helped to forge Kodak's early successes with cheap cardboard cameras. This particular derivation of the format was manufactured with less wood and more metal and came with an Art Deco-style face (there were a couple of variants) in standard black.

The EKC logo visible on the side of the box brings to mind a camera on a tripod arrangement, though in these earlier decades, there seemed to be no regular logo style. There were at least half a dozen different approaches (mainly typographical) seen within the pages of the *British Journal of Photography* almanac between 1930 and 1940. There is a story that Eastman was particularly fond of the letter K and used it as a starting point when establishing the company name, thus a 1930 logo was the letter K in a circle.

This beautiful sample produced between 1934 and 1942 and costing $2.25 was difficult to open (possibly broken), though this may have been a slight design flaw. It has been reported that users occasionally had to take the camera to a photographic shop to get the old film taken out and a new one put in—especially annoying as you only got eight pictures on a roll of film.

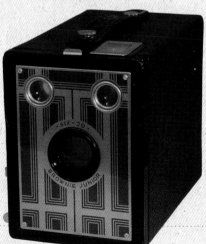

A Six-20 Brownie with the popular Art Deco-style design on its metal face plate.

Dimensions:		Country:	Lens:
H **3.9in / 100mm**		**USA**	**Diway**
W **3.15in / 80mm**			Film:
L **5.1in / 130mm**			**120**

Above and Right: *Graphics from 1930s film envelopes. Graphics in chemist's shops also endlessly promoted Kodak film.*

Bottom: *A Six-20 Brownie Junior in its original box.*

Above: *Instruction manual cover.*

21

Ensign
MIDGET 1934

Not all early cameras were ponderously bulky, as this elegant design classic demonstrates. A miniature in the true sense of the word, the Ensign Midget was designed by the Swedish engineer Magnus Niell who actually patented it back in 1917, seventeen years before Ensign put it into production. It measured a tiny 9 × 4cm and shot six negatives (4 × 3cm) on E10 film. According to a review in the 1935 *British Journal of Photography* almanac, the camera "...will sell on sight, because of its minimum size and natty appearance. A girl will call it 'sweet' and will want to be given one."

Ensign's own marketing described it as "a bare half-inch longer than a packet of cigarettes" and were quick to point out during the Second World War years that it "goes into a tunic pocket, with room to spare." The Midget sold very well for 30 shillings, the average weekly wage—thanks to clever marketing and ease of use. Such

was its popularity that film was still being made for it more than 30 years after it stopped manufacturing the camera.

Released in 1934, it came in bright packaging with a smart little instruction manual that was exactly the same size as the camera.

Left: *Box art.*

Right: *Pages from the instruction manual.*

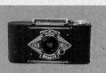
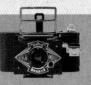
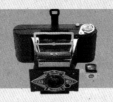

Dimensions:		Country:	Lens:
H	1.5in / 40mm	**UK**	**Ensar Anastigmat**
W	3.5in / 90mm		*f*/6.3–*f*/22
L	2.5in / 60mm		Film:
			E10

Above: *When folded, the Midget had no protruding edges that could catch on clothing or the inside of a handbag. Initially, there were two models, the A/D and the A/N, both with an Everset three-speed shutter. Both had a very practical frame viewfinder and a reflecting viewfinder with a pivot for landscape or portrait shots.*

Right: *Pictures of gallant airmen were popular in advertising during the Second World War—and patriotism helped Ensign sell cameras.*

Below: *Adverts for the Ensign Midget emphasized the suitability of the tiny new camera for use by women and used the advertising line, "Wear it always, like your watch."*

FOR PORTRAITURE

. 'Ensign' products will play a pro-
g trade leadership for British skill
New levels of technical excellence
Ensign has helped to establish them.

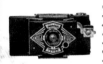

If a horizontal picture is required it can be swung out on its bracket (Fig. 2) and the view will then be between the corners thus!

Fig. 2.

The DIRECT-VISION VIEW FINDER is a frame folded down on the lens front, and a back sight on the camera back. Lift up the top half of the folded frame and continue to lift until the second section rises (Fig. 3) and both click into the upright position. Swing up the back-sight against its stop.

Fig. 3.

Objects between these distances may be provided for by intermediate positions of the pin, thus half-way between 12 and 8 will be correct for 9 to 10 feet, etc. Both Cameras have the same shutter with settings for three Instantaneous speeds, 1/25th, 1/50th and 1/100th second (approximately), also Bulb and Time.

The trigger is just behind the lens front on the right side (opposite the view-finder) where is it well protected from accidental operation. Here is situated also the leg for standing the camera erect when taking an upright picture (Fig. 6). Before closing the Camera the Brilliant View-finder must be returned to its original vertical position.

Fig. 6.

WHEN CLOSING THE CAMERA care is necessary in order to avoid pressing the bellows folds in; hold the four struts with the thumbs and second fingers of each hand, thus leaving the fore-fingers free to press on the front, whilst a slight outward

Fig. 7.

Fig. 8.

pressure is given to the struts (Fig. 7) until the front is free.

TO OPEN THE BACK, slide the top catch, as indicated by arrow, and lift off back by grasping it just below the winder, where a small stud furnishes a grip. The back unhooks at the lower end (Fig. 8).

WHEN REPLACING THE BACK it is important that the two corresponding recesses on the back fits into the body. It is easier to do this if the camera is held with the bottom and upper-most (Fig. 9). For convenience in loading the films both carriers are made to swing out from the spool chambers, but they are permanently attached and cannot be lost. The upper one must, before attempt to swing out, be freed by withdrawing the winder; the lower one is free to swing.

Fig. 9.

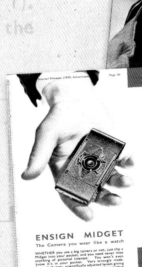

ENSIGN

ENSIGN MIDGET
The Camera you wear like a watch

WHETHER you use a big camera or not, just slip a Midget into your pocket, and you need never miss anything of pictorial interest. You won't even know it's in your pocket. Very strongly made. 3-speed shutter, scientifically adjusted lenses giving pin-point definition at all apertures—making perfect enlarging negatives. Uses Ensign Lukos E10 film.
6 exposures 6d.
With All-distance Lens 30.-
" Ensar Anastigmat f/6.3 30.-

ENSIGN, LIMITED, HIGH HOLBORN, LONDON.

BRITISH THROUGHOUT

1900-1949

Kodak
JIFFY VEST POCKET 1935

Kodak products appear in this book more often than any others and it is testament to the business acumen, pioneering spirit, and ingenuity of George Eastman that the company he formed in 1881 made it well into the twentieth century before hitting harder times. In fact, the crunch didn't come until nearly 80 years after his death in 1932.

He committed suicide when he was diagnosed with terminal cancer, considering his life's work to be done— and what a lot of work it was.

Keeping with the previous Art Deco style, our next item is the attractively styled Jiffy folding camera. Manufactured in a shiny Bakelite finish it was beautiful to look at: elegant, desirable, and very feminine.

It weighed in at only ten ounces and featured a fixed focus lens, a built-in shutter, and a folding eye-level viewfinder. Named Jiffy because of its ease of use—press one button and the front pops out, press another and you take the picture—it was designed around Kodak's 127 film format and was both fashionable and practical, not to mention a big hit with the ladies.

Released in 1935, it had a price tag of $5.

Art Deco styled with a glossy black Bakelite case, the Jiffy Kodak Vest Pocket took eight exposures of 1 5/8" × 2 1/2" on 127 film. Features included a fixed-focus doublet lens, a shutter with Instantaneous and B settings, and a folding eye-level viewfinder.

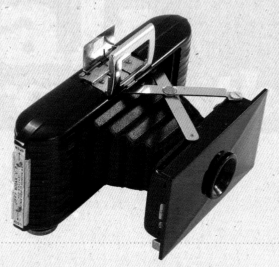

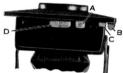

Perfect snaps in every light on VERICHROME Made by Kodak

Dimensions:	Country:	Lens:
H **3.55in / 90mm**	**USA**	**Fixed-focus double lens**
W **5.5in / 140mm**		Film:
L **3.4in / 85mm**		**127**

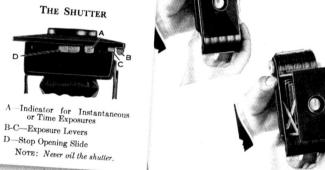

OPENING THE FRONT

THE SHUTTER

A—Indicator for Instantaneous or Time Exposures
B-C—Exposure Levers
D—Stop Opening Slide
NOTE: *Never oil the shutter.*

Right: *Pages from instruction manual.*

Below: *The Jiffy Vest Pocket Kodak was a triumph of compact design for the mid-1930s.*

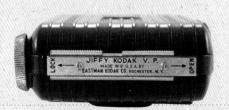

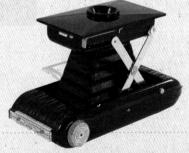

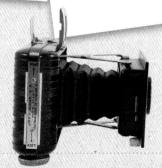

Zeiss Ikon
NETTAR 515 FOLDING CAMERA 1937

Zeiss Ikon was created by the Zeiss Foundation in 1926 as a meld of four German camera companies, each troubled by recession and hyperinflation. The Zeiss Foundation was itself a creation of the famous optical manufacturer, Carl Zeiss Jena, which had been founded by Carl Zeiss with his partner, physicist Ernst Abbe, in 1856. After Carl Zeiss died in 1888, Abbe led a team that created some of the greatest lens designs in history, licensed the designs to other manufacturers (Tessar, Sonnar, Biogon, and Planar in particular), and created the Zeiss Foundation, funded by the proceeds.

The Zeiss Ikon Nettar 515, one of a long series of Nettar folding roll-film cameras, was a compact and beautifully engineered 16-on-120 camera that sprang open at the touch of a button. Made from 1937 until the early part of the Second World War, it was extremely reliable. The company's own advertising claimed it was "as easy to use as a box camera" and reassured customers that "the shutter release on the camera body does much to eliminate camera shake"—an age-old problem that was solved only by twenty-first century image-stabilizing technology. The price of this camera depended on the lens type, and the cheapest version cost £2.12s.6d (approx. $4.12), when the average weekly wage in the UK was only a little over £1 (approx. $1.57) more than that. It shot 16 6.5 × 4cm images on 120 film.

With over 165 years of manufacturing experience, the name Zeiss is synonymous with precision engineering in photography. Still a world innovator, today the Zeiss AG group is involved in making the lenses for Nokia N8 mobile telephones.

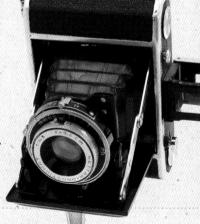

There were several variants of the 1937 Zeiss Ikon Nettar 515. This example has an f/4.5 Novar lens and Klio shutter.

Dimensions:	Country:	Lens:
H **4.7in / 120mm**	**Germany**	**Anastigmat 1:4.5**
W **4.7in / 120mm**		**75mm**
L **3.5in / 95mm**		Film:
		120

ZEISS
IKON

Taken with Contax III, Zeiss Tessar f/2.8, 2" focal length.
1/250th sec. exposure at f/3.5.

ZEISS IKON LIMITED
MAIDSTONE HOUSE, 25-27 BERNERS ST., LONDON, W.1
to whom all enquiries from Great Britain and Ireland may be addressed.
Enquiries for Eire can also be addressed to :
T. H. MASON & SONS, LTD., 5 & 6 DAME STREET, DUBLIN.
Enquiries emanating from other territories should be addressed either to the Zeiss Ikon distributors for the territory, or :
ZEISS IKON A.G., DRESDEN-A.21, GERMANY.

Left: British Journal of Photography *almanac, 1939.*

Right: *1930s Zeiss leaflet advertising Zeiss lenses.*

Below: *This top view shows the back of the camera open, the folding viewfinder erect, and the folding strut under the door that enables the camera to stand firmly.*

27

Purma
SPECIAL 1937

This was a sleek, stylish, unencumbered camera with "no complicated dials or knobs" made from Bakelite so it was light and weatherproof. The whole thing smacked of 1930s design, with smooth and purposeful lines.

However, this very eye-catching product was not just a pretty face—it came with the revolutionary "gravity controlled" shutter system that gave slow, medium, or fast speeds, depending on which way the camera was being held (vertically or horizontally) and the direction of the pear-shaped winder button. Another innovation was the pop-out lens, which only ejected from the body when the lens cap was unscrewed, helping to cut down the problem of taking pictures with the lens cap still on. (Of course, fingers could always be relied upon to get in the way.)

The Purma Special used 127 film and took 16 exposures at 32 × 32mm per film and the camera was packaged in a gold foil box with minimal branding, adding to its aura of exclusivity. The price tag of £2.10s.0d (approx. $3.92) was roughly 65% of the average weekly wage in 1937.

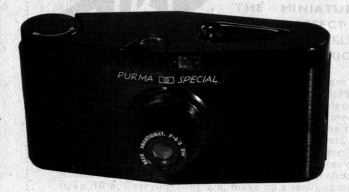

The innovative Purma Special had a three-speed metal focal plane shutter whose speeds were controlled by gravity. The viewfinder lenses were plastic, one of the first uses of plastic lenses in a camera.

Dimensions:		Country:	Lens:
H **3in / 75mm**		UK	**Beck Anastigmat**
W **5.9in / 150mm**			***f*/6.3**
L **2.75in / 70mm**			Film:
			127

1/150 sec. Panchromatic Film Bright sunlight. 2.30 p.m. May. Speed of car 90–100 m.p.h.

THE *PURMA SPECIAL* IS SO SIMPLE. We have only told you at length how to operate it because we want to be sure you cannot make mistakes. We want you to enjoy the thrills of expert photography. It's such a thrill to get that marvellous moment for ever recorded on your film—Jim's dive, Mary's fall, the family unawares, the fleeting moments you wish to treasure. Now it's easy with the simple-to-operate *PURMA SPECIAL*—the camera that ignores the English weather. Get one to-day.

'PURMA SPECIAL' CAMERA

Right: *Cover of instruction manual.*

Left: *A contemporary advertisement for the camera.*

Below: *Two interchangeable lenses.*

PURMA SPECIAL

THE ALL BRITISH
SPEED CAMERA

MAKES
IT SIMPLE
TO BE AN EXPERT

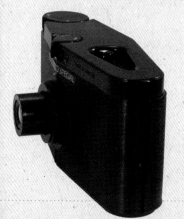

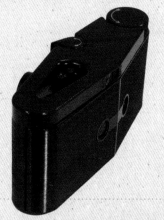

Lumière
ELJY 1937

"The smallest, lightest, cheapest precision miniature" claimed the advert for this product in the *British Journal of Photography* in 1940—and the Eljy was certainly all of that. A quirky, neat little camera, distinct with its rounded corners, a lens that extended out from the body on a tube, and a pop-up viewfinder, it was capable of shooting eight 24 × 36mm negatives (coincidentally, the same aperture size as 35mm film) on a 3cm wide roll film. According to the manual, "the special model for the English market has all of the distances engraved in English measurements."

The unusual name is derived from the French pronunciation of the initial letters of Lumière and Jougla, two companies that joined forces to manufacture cameras and film in Paris. (Lumière had the distinction of being the first producer of film in Europe in 1896.) It's possible to imagine this tiny spy camera being hidden away by patriotic resistance fighters during the war, especially as production stopped in 1940, by which time about 25,000 had been made according

to advertisements. The camera was re-introduced in 1944 after the liberation of France, with a further version launching in 1945. A new model with a coated lens and flash synchronization appeared in 1948—though the camera shown here is from 1937 and lacks these.

Early Eljy cameras were date-coded with a letter on the lens mount—G for 1937, H for 1938, and so on. The first Eljy cost £5.5s.0d (approx. $8.23) in the UK, when the average weekly wage was £3.16s.8d (approx. $6.01).

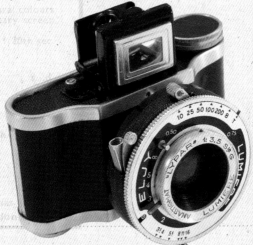

This 1937 Eljy has an f/3.5 lens and a five-speed shutter plus B and T.

Dimensions:	Country:	Lens:
H 2.75in / 70mm	**France**	**Lypar 1:3.5**
W 3.15in / 80mm		*f*/3.5–*f*/16
L 1.8in / 45mm		Film:
		36 × 24mm roll

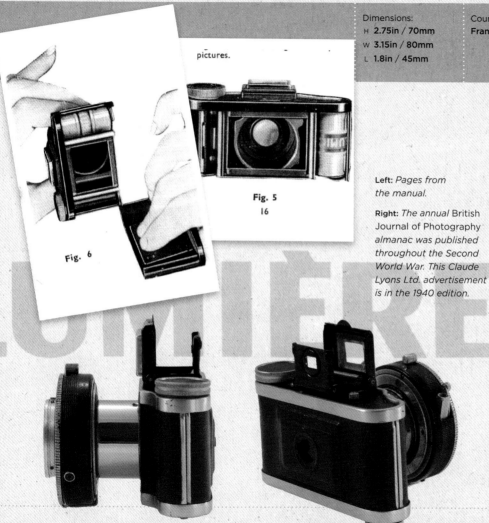

pictures.

Fig. 5

16

Fig. 6

Left: *Pages from the manual.*

Right: *The annual* British Journal of Photography *almanac was published throughout the Second World War. This Claude Lyons Ltd. advertisement is in the 1940 edition.*

THE BRITISH JOURNAL ALMANAC (1940) ADVERTISEMENTS.

This may be your last opportunity to get your Eljy at the pre-war price

MADE IN FRANCE

Increased production costs have already enhanced the price of the Eljy in France, but we foresaw importation difficulties, and secured adequate stocks before the outbreak of war. Hence, while these stocks last, there will be no increase on the modest five guineas, complete, your dealer asks for this amazing camera

THE SMALLEST, LIGHTEST, CHEAPEST PRECISION MINIATURE

The Super Eljy is made in France by Lumière, has f 3.5 fully corrected anastigmat (57 degrees angle of view) in sunk mount, focussing from infinity right down to 20 inches (scale marked in feet). Direct-vision optical finder WITH CORRECTION FOR PARALLAX. Collapsible lens barrel with locking device for extreme rigidity. Accurately calibrated 4-

speed shutter. Tripod bush. "Pan" window. Only 3 × 2 × 1⅜ inches! Weighs only 7 oz. All-metal covered genuine black-grained leather. Truly a marvel of precision engineering. Complete with two 8 - exposure 24 × 36 mm. films, equipoise and cable release FIVE GUINEAS. Eljy Minor, with simplified specification, scale in metres, but identical f 3.5 lens

Write to Mr. B. J. Seller for the 40-pp. art booklet on Eljy photography

CLAUDE LYONS LTD
180/182a TOTTENHAM COURT RD, LONDON, W.I. *Phone:* MUS: 3025
Head Office & Works – Liverpool, 3

31

Ensign
SELFIX 320 1938

Ensign had become a formidable force in British camera manufacturing during the first half of the twentieth century. With the Selfix 320, it produced yet another example of a fine, well-engineered folding camera in a very long line of folding cameras.

The largest of the four Ensign cameras in this book, the Selfix 320 was 12cm deep when extended. A previous owner of this model had adhered a note to the inside of the camera reminding themselves, or future users, that it: "takes film Kodak 120—19th Jan, 1940." This was probably to avoid any confusion with the newer, smaller 127 film. With the Selfix, you could shoot either eight 6 × 9cm images or, with the addition of a metal plate with a smaller aperture, 16 6 × 4.5cm images. The usual Ensign quality of finish is in evidence here, with the camera covered in fine-grain leather cloth with a black enamel and chromium plate.

Its price at £2.10s.0d (approx. $3.92) for the cheapest version was about 62% of an average week's wages in the UK. The essential Britishness shines through in the advertising copy—you can just imagine the clipped tones in phrases like "a handsome and beautifully fitted camera" and "It makes a capital present that will yield its owner absolutely first class pictures for years."

This Selfix 320 has an f/6.3 Ensar lens in a three-speed Ensign shutter, but there were various lens and shutter combinations available.

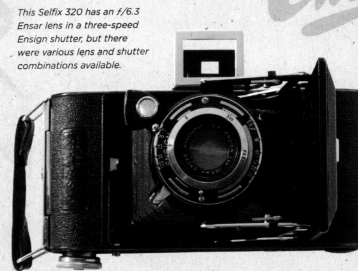

Dimensions:	Country:	Lens:
H **6.3in / 160mm**	UK	**Anastigmat** *f*/6.3 **105mm**
W **3.15in / 80mm**		Film:
L **4.75in /120mm**		**120**

Fig. 9

Left to Right: The advertisements made much of the fine results and excellent engineering.

Right: In this picture the folding frame viewfinder is closed—it is open in the picture on the left. Note the complex struts for folding the camera.

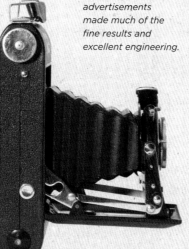

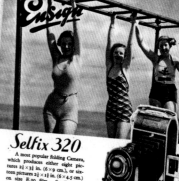

Monarch
FLEXMASTER 1940–44

In complete contrast to the other items in this chapter, this cheap and cheerful plastic camera—manufactured by the Chicago-based Monarch Manufacturing Company—was modeled (looks-wise) on the twin-lens reflex format. Quaint, with very basic working parts, it was designed to use 127 film, shooting half frame 3 × 4cm-sized images giving 16 exposures per roll. This was a trend that started in depression-era cameras and continued into the more low-brow end of the market. Cost was perhaps also a factor in the instruction manual image not being updated to represent the different chrome-plated flip-up viewer of the actual boxed camera.

The design of the Flexmaster is representational of utilitarian, off-the-peg 1940s American manufacturing with the distinctive branding printed onto the circular plate on the front face able to be rebadged for identical, but differently named cameras, offering a pseudo-exclusivity to customers.

This concept was later on adopted by Hong Kong's mass producers of the cheap and cheerful models that really were more like toys than real cameras.

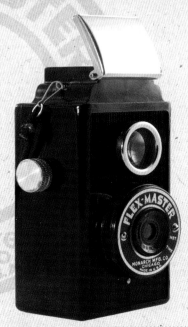

Despite its price, the Flexmaster was a pretty little thing, with distinctive metallic lettering on the front.

Dimensions:	Country:	Lens:
H 6.3in / 160mm	**USA**	**Graf 50mm**
W 2.75in / 70mm		**f/7.7–f/16**
L 2.5in / 60mm		Film:
		127

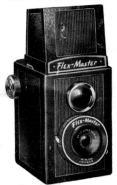

Guarantee

The Flex-Master camera is unconditionally guaranteed against defective workmanship and materials for a period of one year. If you find, however, that your camera needs servicing, return it to the factory with 50c and this guarantee to cover postage and handling. A service charge for parts will be added if camera has been misused or broken.

CAUTION

To obtain best results, subject to be photographed should be at least 8 feet away from camera.

Printed in U.S.A.

INSTRUCTIONS
FOR TAKING PICTURES WITH THE
FLEX-MASTER

A Product of the
MONARCH MFG. CO.
711 West Lake Street
CHICAGO, ILL.

MK 203

Above: *Instruction leaflet with guarantee.*

Above Right:
Original packaging.

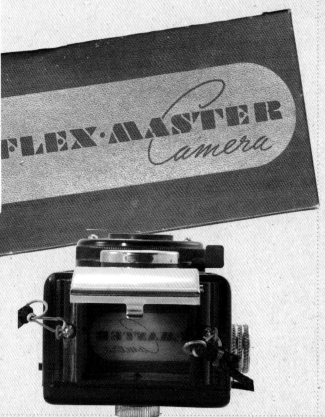

Kodak
BROWNIE REFLEX 1946

The example shown here is the UK version, released in 1946, six years after the USA model, and discontinued in 1960. Another Brownie, another camera for the masses, it re-emphasized the Kodak mantra of "You press the button, we do the rest" and sold in millions. Cheap (of course: it was a Brownie after all), made of plastic and pressed metal, it had a bright, flip-up viewfinder and used Kodak's 127 film.

Oddly enough, the big lens on the front face was the viewing lens, while the smaller one was the actual photographic lens. The winder button was on the base and the exposure button low down on the body. Modern looking and easy to use, its other selling point was that you could attach a flash unit via the two-pin socket underneath the lens. The box graphics proudly announced "with flash contacts," and as pointed out in a 1950s advert, most modern Kodak and Brownie cameras were flash synchronized. The company claimed the bragging rights by boldly stating that "By prolonging indefinitely the amateur's 'day' our cameras are helping

to revolutionize popular photography." (Note that yet another version of the Kodak logo appeared in the advert for this product.)

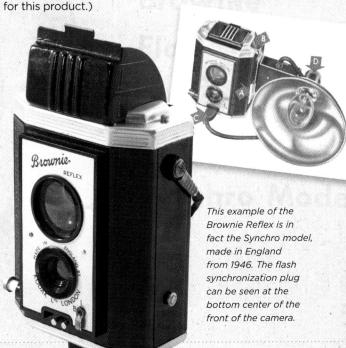

This example of the Brownie Reflex is in fact the Synchro model, made in England from 1946. The flash synchronization plug can be seen at the bottom center of the front of the camera.

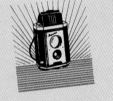

Brownie REFLEX

KODAK LIMITED, LONDON.

Dimensions:	Country:	Lens:
H **6.1in / 155mm**	**UK**	**Meniscus**
W **3.55in / 90mm**		Film:
L **2in / 50mm**		**127**

Left: *The specially designed bulb flash unit for the Brownie Reflex attached to the side of the camera, with its synchronization lead plugged into the front.*

Right: *Characteristically bright Kodak graphic design on the packaging and instruction books for the Brownie Reflex and its flash unit.*

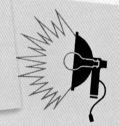

Load the film in subdued light—never in direct sunlight or strong artificial light.

Right: *A 1953 advertisement in the* British Journal of Photography *almanac shows some of the Kodak camera range at the time, from the Brownie 127 at the top to the Cine-Kodak Eight-55 movie camera at the bottom.*

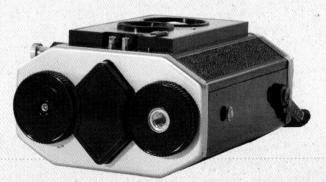

8 The British Journal Almanac
(1953) Advertisements

Kodak CAMERAS

for Amateur Photographers

KODAK 'BROWNIE' 127 CAMERA
A new miniature-style snapshot camera. No focusing; optical direct vision viewfinder; press-button shutter release; 8 pictures 1⅝ × 2¼ inches on 127 'Kodak' film.

SIX-20 'BROWNIE' CAMERAS, C, D & E
Popular snapshot cameras taking 8 pictures 2¼ × 3¼ inches on 620 'Kodak' film. Model D has built-in close-up lens; Model E has built-in close-up lens and filter.

'BROWNIE' REFLEX CAMERA
Hooded reflecting finder shows picture almost full size; no focusing; press-button shutter release; 12 pictures 1⅝ inches square on 127 'Kodak' film.

KODAK 'DUAFLEX' CAMERA
Big reflecting viewfinder; press-button shutter release; takes 12 pictures 2¼ inches square on 620 'Kodak' film.

KODAK 'JUNIOR' I and II CAMERAS
Two new folding cameras taking 8 pictures 2¼ × 3¼ inches on 620 'Kodak' film. Model I: meniscus lens, single-speed shutter. Model II: 'Anaston' f.6.3 lens, synchro 2-speed shutter. (Export only.)

SIX-20 FOLDING 'BROWNIE' CAMERA
Takes 8 pictures 2¼ × 3¼ inches on 620 'Kodak' film. Eye-level optical viewfinder; focusing 'Anaston' f.6.3 lens and 2-speed 'Dakon' shutter. Also with fixed-focus meniscus lens, single-speed shutter (without flash contacts).

SIX-20 'KODAK' A CAMERA
For more advanced amateurs. 8 pictures 2¼ × 3¼ inches on 620 'Kodak' film; eye-level optical viewfinder; body shutter release; with 'Anastar' f.6.3 or f.4.5 lens; 2 or 4-speed shutter.

'CINE-KODAK' EIGHT-55 CAMERA
The best introduction to home movies for the amateur. Loads with 25 ft. of 8 mm. 'Cine-Kodak' film (giving 50 ft. for projection); 13 mm. 'Lumenized' f.2.7 lens; push-button exposure release. Eye-level view-finder.

These cameras have flash contacts for use with accessory 'Kodak' Flasholder.

Chapter 2
1950–1959

This decade, unlike the austere post-war years, showcased an era both prosperous and peaceful.

New technologies and unfettered design ingenuity saw manufacturers move on from old ideas, helped in the latter part of the decade by the 35mm film format that was becoming so popular. Being smaller than the traditional 120 and 127 films, it allowed for slimmer, more compact cameras to be built. The public became more comfortable with the idea of shooting home movies on cine film and along came the revolutionary "instant" film from Polaroid.

The European contribution was still based on quality engineering, even in the lower-end items, and the Americans were producing more glamorous and aspirational products that pointed towards a bright, optimistic future, helped along by large amounts of advertising, more important than ever in this busy, competitive marketplace.

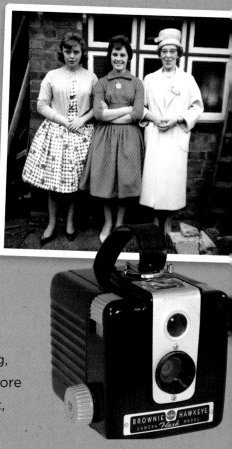

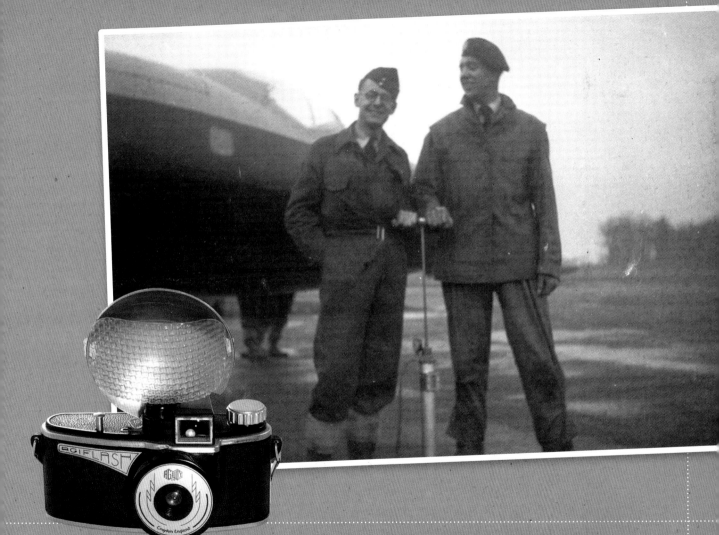

Kodak
HAWKEYE FLASH 1950

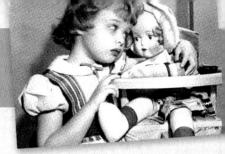

In production for over 10 years from 1950 and identical to the Hawkeye that didn't have any flash capability, this boxed item was accompanied by a fantastic 32-page booklet. Within those pages, the Kodak philosophy was hammered out to optimistic customers who were ready to embrace this modern technology and throw off any reservations they might have had about taking photographs.

The reader was urged on by comments such as "There was a time when cameras were brought out of hiding only for vacations or special occasions... the new thinking is to keep a camera handy so that the unposed, on-the-spot-situations right around home can be pictured." The Hawkeye was a smart-looking Bakelite camera with a typically huge flash unit (and lamps to match) that had a big winder knob and a chunky shutter button. It embraced the cutting-edge 1950s style seen in all sorts of domestic products of the era, including transistor radios, fridges, and food mixers. Kodak were shifting vast numbers of its own design-led products to

the new prosperous post-war consumers. This camera came as part of a boxed outfit, complete with flash holder, lamps, two rolls of Verichrome 620 film, and Photoflash batteries—quite a package.

The Hawkeye Flash was a molded plastic camera with a simple meniscus lens that shot 12 pictures 2 1/4" × 2 1/4" on 620 film. The flash unit fitted to the side of the camera.

Dimensions:	Country:	Lens:
H **3.55in / 90mm**	**USA**	**Meniscus ƒ/15 lens**
W **4.3in / 110mm**		Film:
L **4.3in / 110mm**		**620**

Brownie

Hawkeye Flash Outfit

Right: *The unusually large reflector of the Hawkeye flash unit helped to provide a broad, even spread of light from the flash. Note the test button on the top of the flash unit—users screwed a torch bulb into the flashbulb socket to check whether the battery was working.*

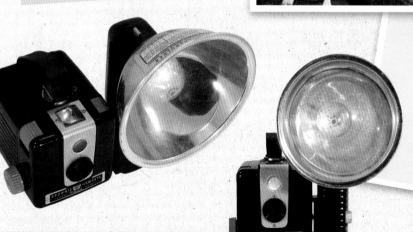

41

Truvox
WEMBLEY SPORTS 1950

The components of this camera were manufactured in 1950 by Truvox—a leading manufacturer of loudspeakers and tape recorders based in Wembley, a suburb of London—but was marketed by another company. A version called the Arti-Six, different only in having the Arti-Six name moulded on the outside back cover, rather than "Wembley Sports," was marketed in France. It shot eight exposures on 120 film.

Perhaps the name was chosen to cash in on the immense popularity of soccer in the UK, referencing as it did the famous Wembley football stadium. However, this model was anything but sporty. Bulky yet lightweight due to its mainly Bakelite construction, it had a huge screw-in lens unit to allow the photographer to focus on his subject (known as Helical focusing—based on a helix or spiral). Nothing actually came into focus as you twisted the lens and looked through the viewfinder, as you had to pre-set the lens to one of four distances (4ft, 6ft, 13ft, and Infinity)—by which time the goalie would be picking the ball out of the back of the net. Nevertheless, the sporting theme continued with the optimistically named Sportar lens and the Rondex Rapid Shutter. The price for this camera was £5.12s.6d (approx. $15.70), and the UK average weekly wage in 1950 was £9.11s.0d (approx. $26.65). Interestingly, the rubber-stamped address on the booklet reveals the retailer to be based in Palmers Green, North London—not many miles away from Wembley Stadium.

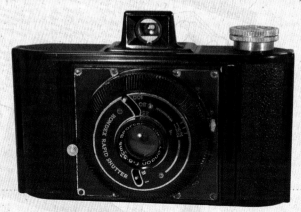

The Wembley Sports shutter offered three speeds when set to "instantaneous" (1/25, 1/50, and 1/100), and there were three apertures: f/11, f/16, and f/22.

Dimensions:	Country:	Lens:
H 4.1in / 105mm	**UK**	**Sportar 1:11**
W 6.1in / 155mm		*f*/11–*f*/16
L 3.9in / 100mm		Film:
		120

Wembley Sports

THE CAMERA WITH 10 STAR FEATURES

* TAKES FULL 3¼" x 2¼" PICTURES (SIZE 20 FILM).
* 'SPORTAR' LENS 8.5 cm., *f*/11 (COATED).
* THREE LENS APERTURES : *f*/11, *f*/16, *f*/22.
* RONDEX RAPID SHUTTER 1/25, 1/50, 1/100 SEC. AND TIME EXPOSURE SETTING.
* FOCUSSING SCALE FROM 4ft. TO INFINITY, WITH INSTANT SETTING.
* DIRECT VISION OPTICAL VIEW FINDER.
* BUSHED FOR CABLE RELEASE AND TRIPOD.
* DETACHABLE BACK FOR EASY LOADING.
* PERMANENTLY LIGHTPROOF (NO BELLOWS)
* HANDY SHAPE—EASY TO HOLD.

PICTURES THIS SIZE —NO NEED TO ENLARGE

PRICE £5 12s. 6d.

Above: *Pages from the instruction manual.*

Below and Right: *Camera with instructions and original box.*

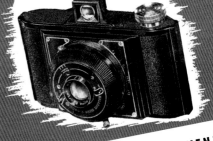

Revere
MODEL 44 8MM CINE 1952

With only one lens screwed into the tri-lens turret, this movie camera always reminds me of a surprised-looking face. Slightly goofy appearance of this model aside, the Revere Camera Company began by making car radiators, something that might go some way to explain the weight of this little beauty. The Revere company was based in Chicago and operated under the banner of the Excel Radiator Company. Apparently, Revere's name came from the Revere Copper Company who provided financial support for Excel during the Depression.

Revere cameras were always at the lower end of the budget range until, in the 1950s, the company astutely purchased a supplier, Wollensak Opticals, who had made lenses for Leica. This enabled Revere to make cameras with much better lenses and more stylish casings. Small,

This weighty 8mm movie camera (over a kilogram with three lenses fitted) was usually sold with a 13mm f/2.5 Wollensak Cine Raptar, a 38mm f/3.5 Wollensak Raptar long-focus lens, and a 7mm f/1.9 Elgeet wide-angle lens.

but solid, this example fits into the palm of the hand, has a clockwork winder, shoots 8mm film, can take a combination of three Wollensak lenses (rotated into place as desired) and was definitely built to last. A leather-look finish, anodized metal body effect, and a chrome plate offering exposure settings in different lighting conditions gave it a beautiful 1950s look.

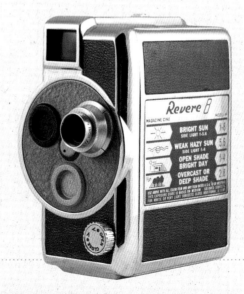

Dimensions:	Country:	Lens:
H 4.5in / 115mm	USA	Wollensak *f*/2.5
W 2.6in / 65mm		Film:
L 4.5in / 115mm		8mm

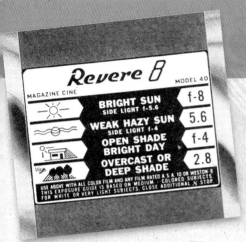

Left: *Exposure guide on the side of the camera.*

Below and Right: *The instruction leaflet, with very bright cover.*

HOW TO LOAD THE CAMERA

The film magazine should never be exposed to direct sunlight. When handling it outdoors, remove from carton only in subdued light.

Turn door lock completely in "open" direction. Be sure that the "open" dot on door knob *lines* up with the dot on camera. Door will spring open.

Door opens wide to permit easy, smooth insertion of film magazine. Be sure that "open" dot on door lock lines up with dot on camera while inserting magazine.

Insert magazine under door catch, slide forward and press down. Side marked. "This Slide Up For First Exposure" should be face up for first 25 feet, then reversed to complete 50-foot roll. Close door tight and turn door lock completely in "close" direction. Be sure that "close" dot on door knob lines up with the dot on camera.

—5—

HOW TO UN...

Simply lift out magazine. ◄

Close door tight and turn door lock completely in "close" direction. Be sure that "close" dot on door knob lines up with dot on camera.

—6—

Kodak
BROWNIE 127 1953

The humble Brownie 127 began its life in Kodak's Harrow factory in 1952 and was a huge hit with the public. In the first two years of production, this shiny plastic snapshot camera sold over two million units in the UK and has since become a design classic. It was made of Bakelite, a hard, mouldable plastic invented by New York chemist Dr. Leo Baekeland in 1909. He'd previously made Velox photo paper which was purchased by Kodak for a small fortune of $750,000, which enabled him to research his new plastic from a home laboratory.

The model shown here was found recently in a thrift store in mint condition, complete with operating instructions, box, and even its Design Centre tag, more than 50 years after it was introduced in the UK. This was the second version of the model, with a flatter top and vertical lines on the sides, and produced eight exposures on 127 film, each 6 × 4.5cm.

Produced in England in 1953, it had an affordable price tag of £1.5s.0d (approx. $3.48), which was, in the UK, less than a day's pay.

The typically 1950s styling of the Brownie 127 is timelessly attractive. As long as you can get your hands on some 127 film, a Brownie 127 can still be used to take good photographs.

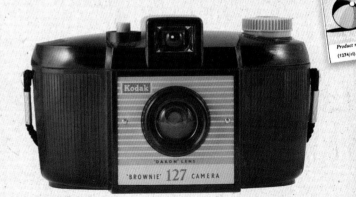

Dimensions:		Country:	Lens:
H 3in / 75mm		UK	Dakon
W 4.7in / 120mm			Film:
L 2.75in / 70mm			127

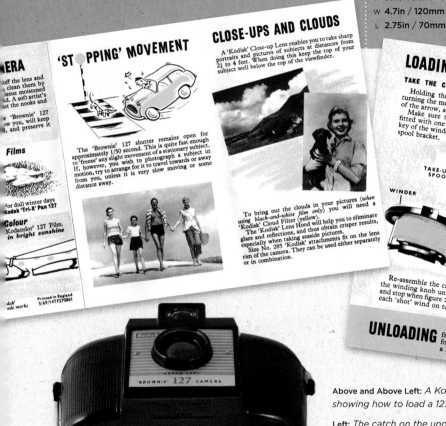

'STOPPING' MOVEMENT

The 'Brownie' 127 shutter remains open for approximately 1/50 second. This is quite fast enough to 'freeze' any slight movement of a stationary subject. If, however, you wish to photograph a subject in motion, try to arrange for it to travel towards or away from you, unless it is very slow moving or some distance away.

CLOSE-UPS AND CLOUDS

A 'Kodisk' Close-up Lens enables you to take sharp portraits and pictures of subjects at distances from 2½ to 4 feet. When doing this keep the top of your subject well below the top of the viewfinder.

To bring out the clouds in your pictures (when using black-and-white film only) you will need a 'Kodisk' Cloud Filter (yellow).

The 'Kodisk' Lens Hood will help you to eliminate glare and reflections, and thus obtain crisper results, especially when taking seaside pictures.

Size No. 285 'Kodisk' attachments fit on the lens rim of the camera. They can be used either separately or in combination.

(partial left column)

...off the lens and ...clean them by ...issue moistened ...ut the nooks and

'Brownie' 127 ...w, you will keep ..., and preserve it

Films

...or dull winter days Kodak 'Tri-X' Pan 127

Colour
Kodacolor 127 Film. in bright sunshine

Printed in England
5/69/14TF270861
...dak'
...ade marks

LOADING Size 127 film only

TAKE THE CAMERA INTO THE SHADE

Holding the top of the camera, unlock it by turning the metal key in the base in the direction of the arrow, and separate the two parts.

Make sure that the empty (take-up) spool is fitted with one of the end slots engaged with the key of the winder and the other end in the sprung spool bracket.

1

Clip the film spool in position with one end in the hole in the feed-spool bracket and the other end in the moulded bearing hole. Carefully remove as much of the sealing band as possible.

2

With the coloured side outward draw the backing paper along the curved film track and thread the tongue as far as it will go into the long side of the slot in the take-up spool.

Turn the winder in the direction of the arrow about five times. Be certain that the paper is winding tightly and evenly between the spool flanges.

3

Re-assemble the camera and lock by turning the key clockwise. Turn the winding knob until the warning pointer ➤ passes the red window and stop when figure **1** is centred. The camera is now ready for use. After each 'shot' wind on to the next number.

4

TAKE-UP SPOOL

WINDER

SPOOL BRACKET

LOCKING KEY

SHUTTER BUTTON

UNLOADING

When you have taken eight pictures continue winding until the paper disappears from view in the red window. Open the camera in the shade, remove the full spool, fold the end of the paper under and seal it with the paper sticker. Hand the film to a Kodak dealer for developing and printing.

Above and Above Left: A Kodak instruction leaflet showing how to load a 127 film into the Brownie 127.

Left: The catch on the underside of the Brownie 127 releases the body to slide out of the external shell for film loading.

Agilux
AGIFLASH 1954

Based in Croydon, England, Agilux was a subsidiary of Aeronautical & General Instruments Ltd., and the Agiflash is a retro design classic. Well-constructed, the body is made of plastic moulding covered in black-grained leather with satin chrome trim. The model is simple to operate, taking eight 6 × 4.5cm pictures on 127 film. The Agiflash has the honor of being the first British camera with a built-in flash-bulb holder (under the cap marked "flash"), which was fired by a capacitor powered by batteries housed in the body. Amusingly, back in 1954 the *British Journal of Photography* observed that "both the components in flash equipment and the bulbs that are used with it have become so much smaller in physical dimensions that it is a logical step to incorporate the flash unit into the camera." The bulbs were, in fact, whoppers, measuring about 2.4in in length. A plug-in reflector slipped into a socket behind the lamp and a curved lever ejected the spent bulb.

There's a definite eccentricity to this camera, from the streamlined styling and the fragile-looking reflector that comes in two pieces, to the Agiflash logo style and the wild typography of the little flash cap. There's a "golden rule" in the camera manual that advises when shooting in bright sunlight to make sure "that the lens is in the shade by asking someone to hold a newspaper high above the camera."

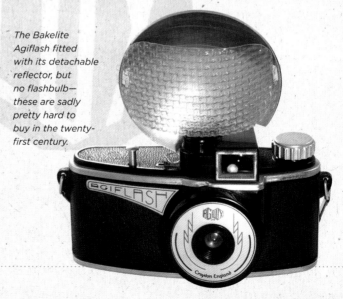

The Bakelite Agiflash fitted with its detachable reflector, but no flashbulb— these are sadly pretty hard to buy in the twenty-first century.

Dimensions:	Country:	Lens:
H 3.55in / 90mm	UK	Agilux
W 5.9in / 150mm		Film:
L 2.75in / 70mm		127

1950-1959

Above: *Battery cap for the flash.*

Right: *Page from instruction manual and advertisement from the* British Journal of Photography, *1955.*

Below: *From* Amateur Photographer *magazine, 1955.*

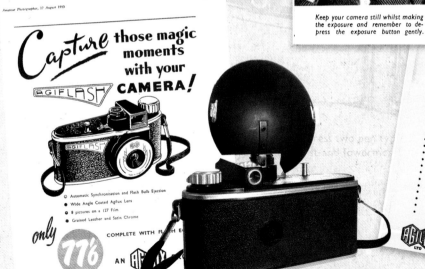

Keep your camera still whilst making the exposure and remember to depress the exposure button gently.

Adox
GOLF 120 1954

2 1/4 x 2 1/4" (6x6 cm) Rollfilm Camera
Description and Instructions for Use.

The main business of the German company Adox was the production of photographic chemicals, film, and black-and-white paper sold under its own brand name. In 1938 Adox purchased the camera factory previously owned by Heinrich and Josef Wirgin, who had been making plate cameras since the 1920s, but were forced to flee Germany due to the political situation before the war. (The brothers did return after the war and enjoyed a successful manufacturing career, producing some excellent cameras.) This model is a viewfinder folding type designed for 120 roll film producing a picture size of 6 × 6cm.

It has a typically tiny reversed-Galilean viewfinder, but is a well-made, elegant, and slim pocket camera measuring only 13 × 9 × 3cm when folded. Adox made a total of seven Golfs, all 6 × 6cm folding cameras. One model, the Messe-Golf, had an uncoupled rangefinder. The company was famous for its Adox 300 35mm with interchangeable film magazines, beloved of European police forces, and for many other 35mm cameras.

The company was bought by Du Pont in 1962, but finally shut up shop in the face of serious competition from the emerging Japanese manufacturers in the early 1970s. This sample was produced in Germany in 1954.

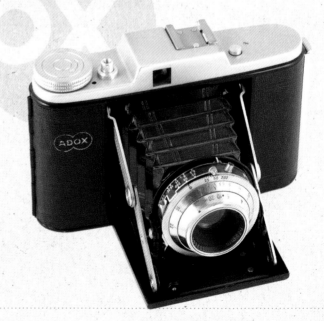

Dimensions:	Country:	Lens:
H 3.55in / 90mm	Germany	Adoxar 75mm 1:6.3
W 5.5in / 140mm		f/6.3–f/22
L 4in / 100mm		Film:
		120

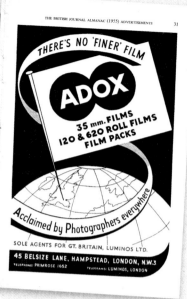

Abb. 3

Left, Far Left, and Below: *Advertisement from the* British Journal of Photography *almanac, 1955, as well as some pages from the instruction leaflet.*

Left: *A Golf 63 of 1954, so called because it had a 75mm f/6.3 Adoxar lens in a Vario shutter. This was the only model in the Golf series that came without delay action.*

Below: *Film in the back of the camera.*

Left: *Advertisement from the Adox Golf, when closed, was genuinely pocketable— although pretty strong pockets were required.*

Ross-Ensign
FUL-VUE SUPER 1954

DESIGNERS REPORT

This model, the last of the Ensign cameras featured in this book, is significant because the "super" referred to in the model name was the culmination of continual improvement on the original model (based on sales in excess of 1 million units) that spanned the 15 years since production began in 1939.

Ross of London had been making lenses since 1830. When it merged with Barnet-Ensign in 1948, all their joint expertise was brought to bear on this well-made, unique-looking camera with its bright, flip-up viewfinder, capable of 12 6 × 6cm frames per roll of 620 film.

After some 70 years of manufacturing cameras, the bright light that had been Ross-Ensign (originally Houghton) dimmed in the early 1960s, its cameras at last becoming old-fashioned looking and expensive as it persevered with its belief that the 35mm format would never catch on. It was the first manufacturer unable to anticipate emerging trends, and was a sad end to a British company that, during the inter-war period, was the largest producer of photographic equipment in the country and highly regarded for its skilful engineering.

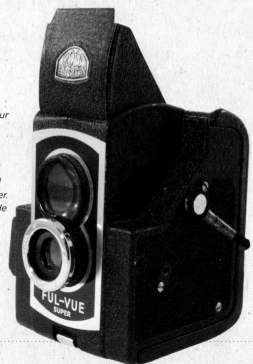

The Ful-Vue Super, which appeared in 1954, was the third of four versions of Ensign Ful-Vue marketed between 1939 and 1959. It had an f/11 Achromat lens and a two-speed shutter. Versions were made in black, gray and maroon, and gray.

Dimensions:	Country:	Lens:
H 5.3in / 135mm	UK	3-point focusing
W 3.15in / 80mm		Film:
L 3.15in / 80mm		620

1950-1959

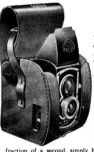

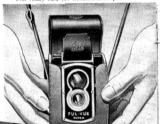

This handsome ever-ready case provides the most convenient way of carrying and protecting your Ful-Vue Super and pictures can be taken without having to remove the camera from its protective case.

fraction of a second, simply by releasing the catch and folding back the top of the case as shown in the accompanying illustration. The case also allows the shutter to be adjusted and the film to be wound on without opening the case. A shoulder strap is supplied.

The camera is locked in the case automatically by the studs on the body, which fall into slots in the ever-ready case. No loose straps are required to hold the camera and yet it can be easily removed for loading a film by pressing on the sides of the case, so as to release the studs from the slots.

How the Ful-Vue Super is used in its ever-ready case for instantaneous pictures.

Above Left: *Advertising leaflet, 1956.*

Left: *British Journal of Photography* almanac, 1927. An advertisement for Ross lenses before Ross merged with Ensign.

Right and Above Right: Detail from the instruction booklet.

ROSS LENSES

By Appointment to H.M. the King

ROSS LIMITED
3, North Side, Clapham Common, S.W.4.
13 and 14, Great Castle Street, Oxford Circus, London, W.1.

ROSS ENSIGN

see what you get with the new . . .

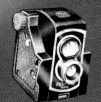

FUL-VUE *super*

Kodak
BROWNIE TURRET 1955

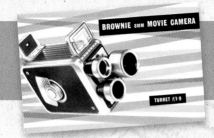

The Kodak Brownie Turret of 1955, with three *f*/1.9 lenses of different focal lengths, was the best and most expensive of a series of Brownie Standard 8 cine cameras that began with the Brownie Movie camera of 1951. The Turret was aimed at those upwardly mobile couples with careers and a lifestyle to maintain. According to the manual, it was easy to use, even for a housewife with freshly manicured nails (a very 1950s endorsement). The camera needed no focusing, though there was a choice of three lenses (24mm, 13mm, and 9mm wide) which were rotated into position.

Flip-up sights on top of the camera meant that you didn't quite get what you saw (an effect known as parallax), but the results were good, although no sound was recorded. To aid the cinematographer the lens barrels were color-coded green, red, and orange, which corresponded with the three rectangles on the forward viewfinder, helping to frame the shot. It used 8mm cine film and was a great camera for those wanting to shoot quality home movies. "It's everybody's movie camera"

proclaimed the instruction manual, and it sold in huge quantities. The serial number on the example shown here suggests that it was one of more than a million Brownie movie cameras produced, although it is impossible to be certain that other Kodak movie-camera models were not included in the serial number sequence.

Available in the USA in 1955 (the same year that McDonalds first appeared), it sold for $79.50 when the average weekly wage was just over $80.00.

Kodak Brownie movie cameras were hugely popular during the 1950s and into the 1960s, in capable hands yielding excellent results on Standard 8 (Double 8) film, usually Kodachrome.

Dimensions:
H 5.1in / 130mm
W 2.4in / 60mm
L 7.3in / 185mm

Country:
USA

Lens:
f/1.9–f/16
Film:
8mm

's as easy as this!

1 wind the motor

2 set the lens opening

3 press the exposure lever

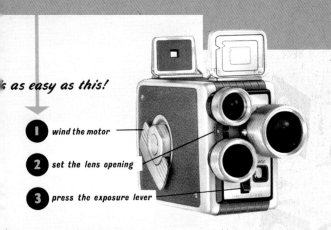

Above, Above Right, and Right: *From the instruction manual.*

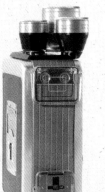

Get to know your
Brownie Movie Camera

before you load it!

It's everybody's movie camera...

Before making any important pictures—of a tour or some special event—it is always well to shoot a roll of film and check the results. This will give you practice in camera operation and provide a check on your equipment. If you have any questions, your local Kodak dealer will be glad to help.

Philips
PHOTOFLUX FLASHBULBS 1955

PHOTAX
FLASH
GUN
with Folding Reflector

In its advertising literature, Philips stated that the "PF" of Photoflux Flash was also an acronym for "Perfection in Flash." These bulbs were introduced in 1955. Phillips' definition of perfection probably differs to that of my father's or uncle's, both of whom recollect yelping in annoyance each time they removed a hot, dead bulb from the reflector unit to replace it with a new one to capture the next wedding or birthday shot.

Before the advent of electronic flash, bulbs were the safer option for practising flash photography. (Previously, flashpowder had been an alternative, but it tended to set fire to hairdos.) In 1958 *Photoguide Magazine* claimed that 10 million flashbulbs were used in Britain and a staggering 800 million in the USA. Even accounting for the population difference, that's still a ratio of about 16:1—possibly the British didn't party as hard.

It's worth noting the ingenuity of the folding fan reflectors of most flash units of the time, which used capacitors charged by batteries to fire the flashbulbs.

The example shown here was made in 1959.

The flashbulb was invented in 1928, in Holland, by the Philips Glolamp Works, Philips Photoflux flashbulbs were key to home photography during the 1950s and into the 1960s, when inexpensive electronic flash units became popular.

Country:
Holland

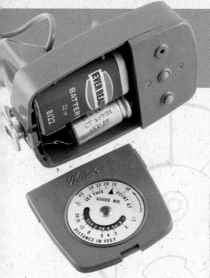

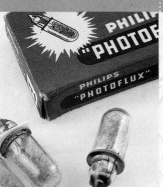

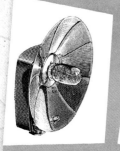

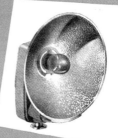

Above: *Battery-powered Photax flash unit and bulbs.*

Right: *Advertisement from the British Journal of Photography almanac, 1960.*

Below Left: *Opening a delicate fan-fold flash reflector required care if damage was to be avoided.*

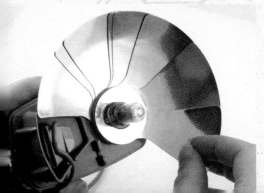

Coronet
FLASHMASTER 1955

The Flashmaster, an unusual-looking camera of Bakelite and metal construction, was one of a long line of budget products produced by the British firm Coronet during its 40-year history. The company was formed in the mid-1920s and was located in Aston in Birmingham, the UK's second city. Aiming itself firmly at the lower end of the market, its products—including brand-name film, flash units, close-up filters, and other accessories—were sold via mail order catalogs. After the war, Coronet had links with the French company Tiranty and the packaging for this camera had instructions in English, French, and German.

Introduced in 1955, when the average UK weekly wage was just under £13 (approx. $36.28), it sold for £1.11s.3d (approx. $4.32) and was advertised as a "popular eye-level viewfinder camera with ultra modern styling." Cavernous on the inside, it took 12 exposures of 6 × 6cm using 120 film and was synchronized for flash photography. The flash unit cost an extra 13 shillings.

This eye-catching camera had box art to match.

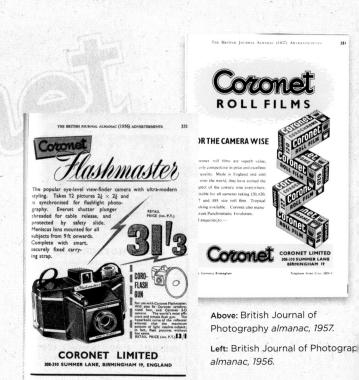

Above: British Journal of Photography *almanac, 1957.*

Left: British Journal of Photograp[h] *almanac, 1956.*

Dimensions:	Country:	Lens:
H **4in / 100mm**	**UK**	**Fixed focus**
W **5.5in / 140mm**		Film:
L **3.5in / 90mm**		**120**

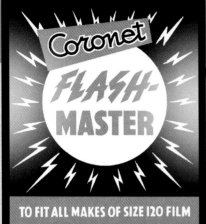

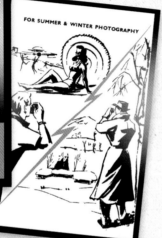

FOR SUMMER & WINTER PHOTOGRAPHY

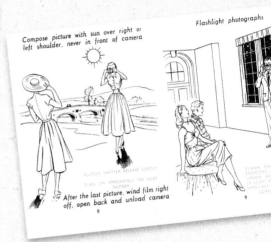

Compose picture with sun over right or left shoulder, never in front of camera

Flashlight photographs

Above and Above Right: *Box art.*

Far Right: *Instruction leaflet.*

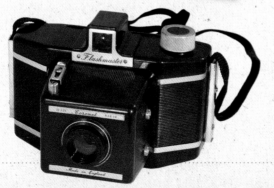

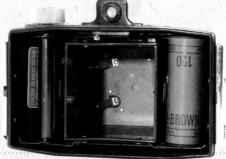

Balda
BALDIXETTE 1956

The name of the 1956 Baldixette camera was, like most other cameras from Balda, derived from the name of the company's founder, Max Baldeweg, who created Balda-Werk in Dresden in 1908. The firm produced quality low-priced cameras, and despite Communist East German authorities "claiming" back the company for the state after the war, Max succeeded in moving to Bünde in West Germany in the early 1950s, where he established Balda Kamera-Werk. It was this company that made the Baldixette and many other post-war Baldas until the mid-1960s. Meanwhile, the East German government changed the name of his nationalized business in Dresden to Belca-Werk, where versions of pre-war Balda cameras were made during the 1950s.

Made in 1956, the Baldixette is typical of the period, with reasonable optics and good build quality. The lens compresses down into the camera body, saving about 1.5in in profile, although the lens-release button tended to enthusiastically project the lens outwards with an alarming "thwack." The viewfinder is a miniscule 4mm², but on the plus side, the shutter operates very smoothly and quietly. The unique lens has three distance settings: 5–10ft, 10–25ft and 25ft–infinity. It has just two aperture settings of *f*/9 and *f*/16 that the photographer switched between via a small lever on the front of the lens.

The Baldixette had a 75mm f/9 Baldar lens that extended out into the taking position.

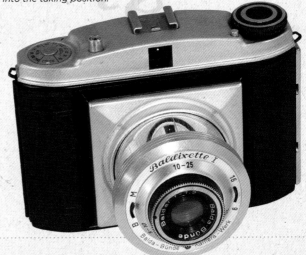

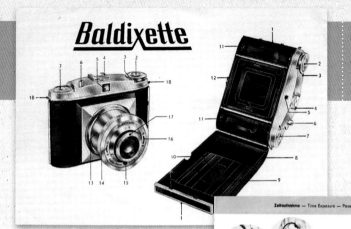

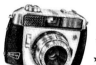

Dimensions:	Country:	Lens:
H **3.55in / 90mm**	**Germany**	**Baldar 72mm**
W **5.1in / 130mm**		**f/9–f/16**
L **3.15in / 80mm**		Film:
		120

1950-1959

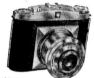

Above and Right: *Front cover and detail from instruction booklet.*

Far Right: *Advertisement from the* British Journal of Photography *almanac, 1959.*

Below: *The Baldixette shot the usual 12 6 × 6cm negatives per roll of film and had a black-grained leather and satin chrome finish with a film-reminder disc on the top plate.*

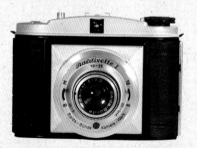

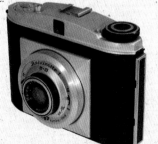

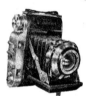

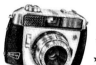

Haking's
HALINA PREFECT 1957

On closer inspection the box art for this camera proclaims it to be "Empire Made," which meant made in the now ex-British territory of Hong Kong, which was given back to China in 1997. Normally, that sentence could mean only one thing—bottom of the barrel, rubbishy products with little of the quality control that British and European manufacturers were so proud of. Ironically, the Prefect seems to be an exception to that rule.

Well-engineered, with an all-metal construction, it was unsophisticated, but reliable, and including tax, cost nearly £4 (approx. $11.40) in the UK in 1957, when the average weekly wage was £15.17s.0d (approx. $44.23).

An attractive piece, finished in a black-grained plastic material with plated trim, it gave 12 6 × 6cm exposures on 120 film and had three aperture settings (f/8, f/11, and f/16).

Haking Enterprises was founded by two doctors in 1956 and specialized in optical products, trading under the Halina brand name out of Hong Kong. Today, the company distributes products in the UK, Ireland, Africa, and the Middle East under the banner of Halina Imaging and is now part of the Haking Group of the People's Republic of China.

With more than 50 years' manufacturing history behind it, Haking has produced an extensive range of 35mm, 110, APS, and digital cameras.

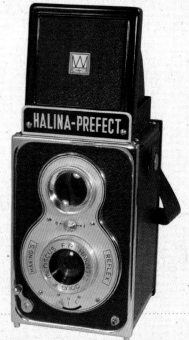

The Halina Prefect looks like a twin-lens reflex, but offers no reflex focusing—the screen under the hood is simply a viewfinder, and the taking lens is a fixed-focus f/8 double meniscus achromat.

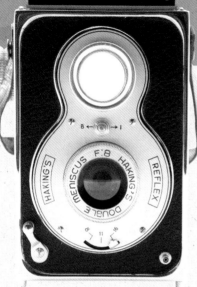

Dimensions:	Country:	Lens:
H **7.1in / 180mm**	**Hong Kong**	**Double Meniscus**
W **2.75in / 70mm**		**ƒ/8–ƒ/16**
L **3.4in / 85mm**		Film: **120**

Below: *Advertisement from the* British Journal of Photography *almanac, 1959.*

Below Left: *Through the viewfinder— note the back-to-front image.*

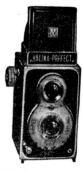

THE BRITISH JOURNAL ALMANA[...]

HALINA AI 2¼" × 2¼"
with 35mm Conversion
★ **HALINA** *f3.5/80* taking lens
★ *f3.5/80* matched viewing lens
★ Coupled front lens focusing
★ 4-Speed shutter ★ Standard
120 Roll Film ★ Synchronised
★ All metal body
Ever-ready case available

HALINA PREFECT
★ Double **MENISCUS** *f8* lens
★ 3 apertures
★ Synchronised ★ All Metal
★ Trigger type body
release ★ 12 Exp. on 120
Carrying case available

Ilford
SPORTSMAN 1957

With the tagline "Taking faces and places with the Ilford Sportsman" planted firmly on the front cover of the instruction booklet and an advert showing the option of a railway bridge or a pretty blonde (you choose...), this camera hit the shops in 1957 and was the first of a series of different Ilford Sportsman models, marketed as Sportina, Sporti, and Sportsmaster cameras over the next decade.

Made in Germany for Ilford by the Dacora Company, the initial order of a modest 1,000 units increased to 50,000 in just a few years. Rigid quality-control inspections revealed that the supply work done by Dacora was of a very high standard and Ilford were particularly pleased with the lenses.

With further modifications and improvements, the various versions of the Sportsman accounted for a substantial part of UK sales of low-cost "family" cameras— not to mention a huge swathe of film sales.

The camera was very slim, sturdy, and of good quality. Unusually, the shutter button was on the front of the camera and as it was pushed horizontally back into the camera body, against the pressure of the photographer's thumb from behind, it helped reduce the possibility of camera shake.

On a historical note, the original company was called Britannia Works and was set up in the late 1870s making photographic plates (at about the same time as a young George Eastman was doing precisely that in the USA). More than 20 years later in 1902, Britannia decided to use the name of the town where it was based. The rest, as they say...

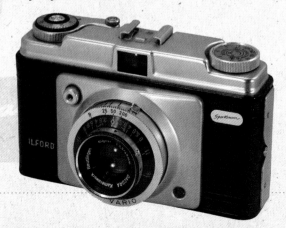

Colour transparencies, colour prints, colour cine:

ILFORD colour is lifelike—real!

Ilfochrome 32 is a fine grain, medium speed film for transparencies that have the natural look.

Ilfochrome 8mm colour film must be sharp—each separate image which may be only 1" high or less in the frame, is often magnified 160 times upon reaching the screen. Ilfochrome 25 has been designed with these stringent requirements in mind, it really is sharp!

Ilfocolor 35mm. Negative colour with an exclusive . . . You get vivid proof prints from the negatives taken in your miniature camera from which to choose the enlargements.

Ilfocolor Roll film. Prints from Ilfocolor Roll film are more lifelike because of the colour mask that is built into the film.

TODAY'S LEADER IN COLOUR **ILFORD** naturally!

11

Dimensions:	Country:	Lens:
H 3in / 75mm	UK	Dacora 45mm 1:3.5
W 4.9in / 125mm		f/3.5–f/16
L 2.6in / 65mm		Film:
		35mm

Left, Far Left, and Below: British Journal of Photography *almanac, 1958. Ilford advertising in the late 1950s was colorful, but not very informative—it tended to assume that the typical camera buyer knew nothing about photography.*

ILFORD

ILFORD LIMITED ILFORD LONDON

Left: *A rebadged Dacora Dignette, the first type of Ilford Sportsman was a reliable family camera with a 45mm f/2.8 Dignar lens in a Vario shutter.*

THE BRITISH JOURNAL ALMANAC (1958) ADVERTISEMENTS 73

ILFORD

For the production of colour transparencies by the reversal process, Ilford 35 mm Colour Films are available in two types, Colour Film 'D' being balanced for use in daylight and Colour Film 'F' for exposures with clear flashbulbs. Exposed films must be returned to Ilford Limited for processing, which is undertaken without extra charge. Both types of films give results of great fidelity, superb definition and outstanding beauty.

Facing page: reproduction from a transparency taken by flash on Ilford 35 mm Colour Film 'F'.

Ilford Sportsman Camera

An inexpensive, precision-made 35mm camera of very attractive design, specially suitable for colour photography. Specification includes a bloomed f/3·5 anastigmat lens of 45 mm focal length, flash-synchronised three-speed Vario shutter, and a rapid, lever-operated film-winder interlocked with the shutter release.

Ilford Sportsman Projector

An efficient portable projector for mounted 35mm colour film transparencies and other 2×2 in. slides, weighing less than 3 lb. and measuring only 8½×6½×3½ in. when closed. Available with either a 100-watt or 150-watt lamp in an easily removable unit incorporating reflector, condenser and heat-absorbing filter, it gives a brilliant, pin-sharp picture 3 feet

Weston Master III
EXPOSURE METER 1957

WESTON

It's hard to believe that before cameras had built-in exposure meters, the photographer had either to estimate, from experience, or by using the "sunny 16" rule*, the shutter speed and aperture (*f*/stop) required to expose a picture correctly, or, if the camera had them, set pointers to pictorial graphics indicating sunshine, clouds or rain to match the exposure to the conditions. Alternatively, he or she could use an exposure meter like this Weston Master III, a version of the long-lived Weston Master series launched in 1956. One look at the math involved (the dial on the meter) was enough to make me opt for the visual icon approach. But, if you needed a certain precision for your photography, particularly when using lighting in a studio, the Weston was a top-of-the-range item.

*Set the shutter speed to the ASA/ISO speed of the film (e.g. for 100 ASA/ISO, set the shutter to 1/100 second), then the aperture to: Very bright sun—*f*/16 • Clear sun—*f*/11 • Cloudy sun—*f*/8 • Cloudy dull—*f*/5.6 • Very dull—*f*/4 or *f*/2.8.

The Weston speed ratings—set in the window in the red part of the dial of a Weston II or III, like this—differ from ASA or ISO film sensitivity values approximately as follows: ISO 400=Weston 320; ISO 200= Weston 160; ISO 100=Weston 80. Set the Weston speed to 160 for your ISO 200 film and you will get a correct exposure reading.

Without turning this entry into a science lecture, every Weston meter was sold with an Invercone incident light attachment to measure reflected light from the scene or subject to be photographed (the most common approach) or, with the Invercone fitted, "incident" light

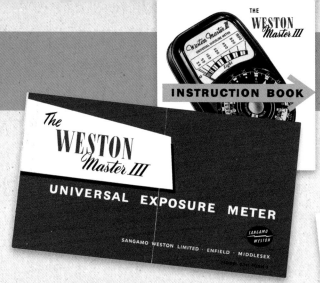

THE
Weston
Master III

INSTRUCTION BOOK

The
WESTON
Master III
UNIVERSAL EXPOSURE METER

SANGAMO WESTON LIMITED · ENFIELD · MIDDLESEX

Dimensions:	Country:
H **3.9in / 100mm**	**USA**
W **2.4in / 60mm**	
L **0.8in / 20mm**	

HIGH RANGE
LIGHT SCALE

FITTING THE INVERCONE

1. Where illumination is relatively low, open the meter's baffle and slip the Invercone into place. The Auxiliary Multiplier is not used.

2. When illumination level requires use of the high light scale, open the baffle and insert the Auxiliary Multiplier.

3. Snap the Invercone into place over the Multiplier.

Above and Right: *From Weston instruction manual.*

Top Right: *Shows how the door over the meter cell on the back of the Weston opens to reveal the window over the cell for low-light readings.*

Above: *Instructions for fitting the Invercone incident light attachment over the meter cell with the door open.*

(light falling on the subject). For this, the Invercone, fitted to the selenium cell window of the meter, on the back, was pointed at the sky, or at the light source, instead of at the subject. Incident-light measurement is more accurate, for color photography particularly.

Sangamo Weston was an American company that specialized in all sorts of electrical equipment and the two companies merged after the death of Edward Weston—the English-born American chemist—

in 1936. Throughout his long and productive life, Weston attained more than 300 patents—mainly for electrical inventions. This example cost about £12 (approx. $33.48) with all the accessories in 1959, when the average weekly pay in the UK was £17.2s.6d (approx. $47.79).

Apparate und Kamerabau
ARETTE 1A 1959

The Arette 1A was one of a series of 17 different 35mm Arette models produced between 1956 and 1960 by Apparate und Kamerabau of Friedrichshafen, Germany. The camera shown here is an example of the second type of Arette 1A, dating from 1959, with a rapid-wind lever on the base of the camera.

German brothers Eugene and Max Armbruster started producing photographic equipment in 1947, initially based in Wildblad, moving to Friedrichshafen in 1949, they are best known for their Akarette and Akarelle series of 35mm cameras. The Arette models were produced as a desperate, and very good, attempt at rescuing the business from bankruptcy, which nonetheless happened in 1960.

Various models were equipped with bright-line viewfinders or built-in exposure meters to compete effectively with the many other contenders for the high-quality 35mm viewfinder camera market at the time.

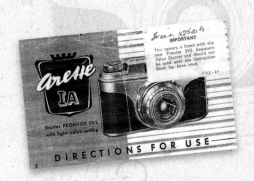

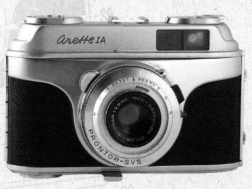

Far Left: *The detailed instruction book for the Arette 1A.*

Left: *This example of the second type of Arette 1A has a Isconar 45mm 1:28 lens in a Prontor SVS shutter.*

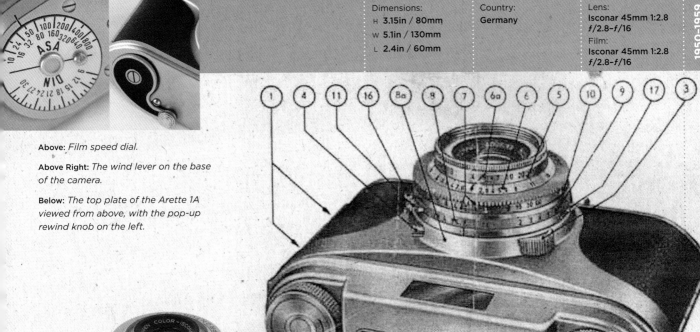

Dimensions:	Country:	Lens:
H 3.15in / 80mm	Germany	Isconar 45mm 1:2.8
W 5.1in / 130mm		f/2.8–f/16
L 2.4in / 60mm		Film:
		Isconar 45mm 1:2.8
		f/2.8–f/16

Above: *Film speed dial.*

Above Right: *The wind lever on the base of the camera.*

Below: *The top plate of the Arette 1A viewed from above, with the pop-up rewind knob on the left.*

Argus
C3 1959

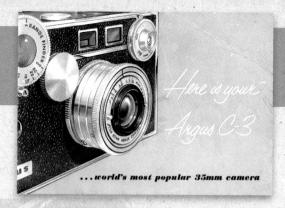

Here is your Argus C3

...world's most popular 35mm camera

Popularized by the Harry Potter films, in which the school reporter used it to take magical pictures, this camera is famous for popularizing the 35mm camera format in the USA. It was in production in various guises from 1939 right through to 1966, which was probably the longest-ever run for a camera. Customer surveys suggested that the proliferation of knobs, dials, and gears made it look "scientific," and therefore, trustworthy. The American public certainly took this product to its heart. Its solid construction and low price ($40 in 1959, when the average weekly wage was $96) helped account for sales of over two million units during its lifetime.

This camera is not my first choice, with its tiny viewfinder and fiddly rangefinder cog that sets the lens distance, although it did have interchangeable lenses and a choice of six *f*-stops. And it certainly looked the business. Production finally ended in 1966 as, initially holding up well against more precise European imports and the cheap high-quality Japanese models flooding the market, the public started to be aware of the C3's shortcomings—namely its old-fashioned design, weight, and clumsiness.

A typical Argus C3—the design changed very little in almost 30 years.

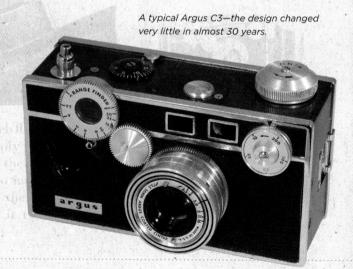

Dimensions:	Country:	Lens:
H 3.4in / 85mm	USA	Cintar 50mm
W 5.1in / 130mm		f/3.5–f/16
L 2.75in / 70mm		Film:
		35mm

15

Above: *The instruction book goes into detail about loading film, and here, about how to set the exposure counter.*

Below: *The earliest C3s had ten shutter speeds, later reduced to seven and then to five. Early cameras had no accessory shoe and silver exposure counter dials with black figures.*

Lifetime Guarantee

Your Argus C3 camera was manufactured, inspected and tested by skilled camera craftsmen. It is guaranteed to be free of defects in workmanship or material during its lifetime. If any servicing is necessary because of imperfections in materials or workmanship, your camera will be factory serviced without charge.

Argus equipment which has been damaged, mishandled or worn from extended use will be factory serviced at established rates. Used or rebuilt equipment is not covered by this guarantee.

Your Argus C3 camera is automatically guaranteed when purchased. There are no cards to send in or further steps to take.

ARGUS CAMERAS INC., ANN ARBOR, MICHIGAN
ARGUS CAMERAS OF CANADA, LTD., TORONTO, ONTARIO

PART NO. 14857

PRINTED IN U.S.A.

51M 3-55

Subject out of focus

Subject correctly focused

Above Right: *The large serrated wheel protruding above the top plate of the camera is turned with the user's forefinger to focus the camera using the coupled rangefinder.*

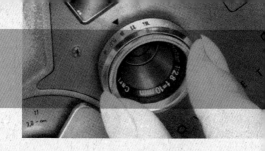

Zeiss Ikon
MOVINETTE 8 1959

The Movikon 8 of 1952 and the less expensive Movinette 8 of 1959 were a radical departure from the norm as they were designed to be held like a stills camera rather than cupped in the palm of the hand or clutched via a pistol grip.

Precisely engineered, as you would expect from one of the world's great camera manufacturers, the Zeiss Ikon Movinette had a sublimely smooth and quiet clockwork motor. Its ergonomically positioned shutter button helped to prevent camera shake and was smoothly responsive. The camera shown here has a bluey-gray enameled finish and is surprisingly lightweight. The motor runs for about 25 seconds before fading—not bad for a 50-year-old. This version was showcased in 1959 and was summed up in the *British Journal of Photography* as follows: "Reducing good quality movie making to the simplest possible terms, the Zeiss Movinette is designed for the man or woman who just wants to press the button and leave it at that." I'm convinced this camera has never had a roll of film through it as it's in immaculate condition on the inside, with no sign of film dust, and still has its photographic insert showing how to load the film.

In 1959, the average weekly wage was £17.2s.6d (approx. $47.49), and the Movinette cost about £40 (approx. $111.63), including purchase tax.

Here shown front and back, the Movinette 8B was supremely simple to use with few adjustments necessary or possible.

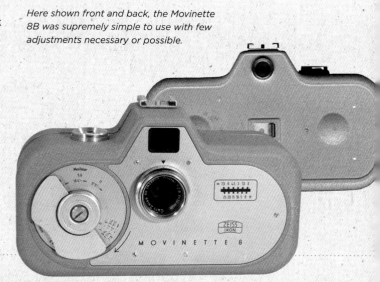

Components of the Movinette

1. Winding key
2. Depth-of-field table for Movitelar tele-converter (under the winding key)
3. Release knob
4. Depth-of-field table for standard Triotar lens and for Triotar with component lenses
5. Accessory shoe
6. Viewfinder window
7. Aperture setting ring
8. Zeiss f/2.8,10 mm Triotar lens
9. Measuring photo-cell of exposure meter *
10. Setting and reading ring of exposure meter *
11. Footage indicator

* Components 9 and 10 are omitted from the Movinette without a built-in exposure meter.

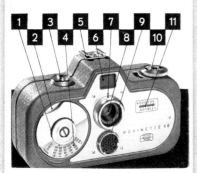

Dimensions:	Country:	Lens:
H **3.55in / 90mm**	**Germany**	Triotar 1:2.8
W **5.9in / 150mm**		**f/2.8–f/11**
L **2.4in / 60mm**		Film:
		8mm

Left: *The Movinette instruction book is extremely detailed, despite the camera's simplicity.*

Right: *Life-size insert from back of camera showing how to load the film.*

Bottom Right: *A spread of the Zeiss Ikon catalog from the late 1950s.*

Right: *Zeiss Ikon offered a movie light accessory for the Movinette and Movikon.*

Below: *The principal differences between the Movinette 8B and its more expensive brother the Movikon 8B were that the Movinette 8B had only a single filming speed and a three-element Zeiss Triotar lens, whereas the Movikon 8B had two speeds (making slow motion possible) and a four-element Zeiss Tessar.*

½ Exp.

NETTAR 2¼" × 2¼" and 2¼" × 3¼"

Beautifully designed light and compact folding cameras for all amateur purposes. Choice of Vario, Novar Anastigmats f/6.3 and f/4.5 coated and colour corrected. Choice of Vario (3-speed) Pronto (4-speed) Velio (5-speed) and Prontor SVS (8-speed) shutters, synchronised for flash, some with delayed action, 100 per cent, self opening at the touch of a button. Double exposure prevention with signal device (except £10 19 4 model), red point setting to facilitate snapshooting, depth of focus scale, accessories and tripod bush. Many accessories available.

Prices for twelve 2¼" × 2¼" pictures with Novar f/4.5, Velio shutter £15 4 0.
... Prontor SVS £22 7 2.
... without double exposure prevention £10 19 4.

NETTAR 2¼" × 2¼" with Novar f/4.5 and PRONTOR SVS shutter ... £22 3 9 1

NETTAR 2¼" × 2¼" £11 10 1 model, shown with Ikoblitz O in position.

IKOPHOT EXPOSURE METER

The most modern of photo electric exposure meters, both in construction and design.

Beautifully finished in off-white housing relieved by gilt. One clearly engraved scale, no calculation necessary. Extremely sensitive exposure range, 60 secs. to 1/1,000 sec.

Suitable for all photography, black and white, colour and cine, filter factors shown on scale, one hand manipulation.

Housing is hermetically sealed.

Compact—3" × 2¼" × 1". Weight only 4½ ozs.

The Ikophot is sold complete with rich brown Ever Ready case, with attachment for incident light readings and gilt safety chain. Price £11 17 8.

MOVIKON 8

NEW CONSTRUCTION, NEW DESIGN, ZEISS IKON PRECISION WORK

Filming holidays, sports events, functions and the family in or out of doors with the new MOVIKON 8 is simpler even than ordinary photography, easy loading, comfortable to hold, silent working, new type finder that can be used with spectacles, no parallax worries, ultra rapid MOVITAR f/1.9 with click stops, self hooded, and helical mount focuses to 8 in.

Removable back, footage indicator. Many accessories £56 16 4 available.

Converter lenses for both wide angle and long distance work.

Movikon 8 with Movitar f/1.9

FOR DOUBLE CINE

Polaroid
80B LAND CAMERA 1959

This model was named after the prodigious and talented inventor Edwin Land who invented "Polarizing" material in 1929, and in the 1940s, went on to manufacture, under the brand name Polaroid, various military hardware such as goggles for airmen, sights for tank gunnery, and guided missile systems. By 1950, Polaroid had produced its one millionth roll of film, and six years later, had produced the same number of cameras. The success story rolled on and on and the statistics piled up: in 1974, an estimated one billion prints are made on instant film; in 1976, six million cameras are produced and Polaroid sue Kodak for copyright infringement; in 1977, Land was awarded his 500th patent and Polaroid sales exceeded $1 billion. Instant film became a global phenomenon.

One of a long line of Polaroid cameras, the 80B came to market in 1959 and was a classic-looking piece of equipment, right down to its "wink light" that enabled flash photography without flashbulbs—although it did resemble something you put on your bicycle to get home in the dark. Constructed in the manner of a folding camera, it was large (accommodating the 8 × 6cm film size) and heavy, especially with the wink-light and its enormous battery in place.

Years after this camera was released, a great victory for Land must have been, after much wrangling, the $925 million payout by Kodak for patent infringement of his Polaroid film.

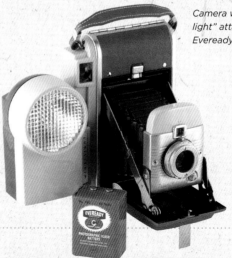

Camera with "wink-light" attached and large Eveready battery for it.

Dimensions:	Country:	Lens:
H 7.5in / 190mm	USA	100mm three-element *f*/8.8–*f*/50
W 4.3in / 110mm		Film:
L 5.9in / 150mm		Polaroid

Far Right: Polaroid's booklet showed how to make good pictures.

Above: ...how to hold the camera to avoid camera shake....

Right: ...how to open the camera correctly to lock the lens standard...

Below: ...and how to use the "Wink-Light" flash.

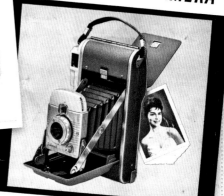

How to make good pictures with your
POLAROID HIGHLANDER
LAND CAMERA

Model 80B

◀ **Without the wink-light**

With the wink-light ▶

Haking's
HALINA 35X 1959

The "instructional booklet" for this sample from the Haking's stable proclaimed this camera was "...robust and attractively designed in all metal, produced to meet the demand for a moderately priced 35mm camera incorporating all the features found on the far more expensive types," which immediately places it near the bottom of the barrel in terms of expectation.

For a small camera it was heavy and basic. There was no hinged back here, just a release screw that separated it into two halves for loading film. Underneath the facade of shiny chrome plate lay some pretty low-brow components, but these were cheaply manufactured components. The bright, colorful box art promised "a camera for good photography," but instead, delivered a kind of miniature poor man's Leica.

There was also a curious clash of logo styles, as the more elegant one on the box bore no resemblance to the one on the cover of the instruction booklet.

An inexpensive cast-metal 35mm focused by distance scale, the Halina 35X had a 45mm f/3.5 lens in a four-speed shutter from 1/25–1/200 second.

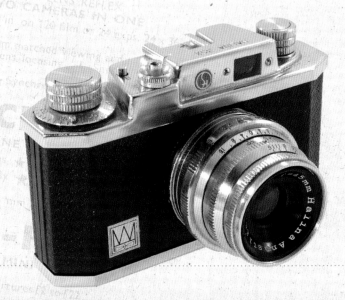

Dimensions:	Country:	Lens:
H **2.75in / 70mm**	**Hong Kong**	45mm 1:3.5
W **4.5in / 115mm**		ƒ/4–ƒ/16
L **2.75in / 70mm**		Film:
		35mm

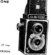

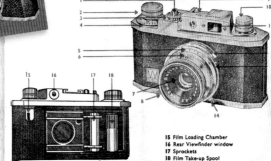

15 Film Loading Chamber
16 Rear Viewfinder window
17 Sprockets
18 Film Take-up Spool

Left: *An advertisement from 1961 by J.J. Silber, the UK agents for Halina products.*

Above and Right: *Details from the Halina 35X instruction book.*

Below: *The baseplate, showing the key that opened the camera, and the front view of the lens assembly.*

Kodak
COLORSNAP 35 1959

At about the time that the Hong Kong sweatshops were bashing out the Halina 35X (see pages 76–77), Kodak's UK manufacturers were working on the Colorsnap 35 (this product retained the American spelling for the word "colour" rather than the US "color").

This simple, easy to use camera combined sleek design and lightweight materials with a price that, at £10.9s.3d (approx. $29.20) was about 61% of a week's pay in 1959. This camera couldn't be more different to the "Empire Made" rival on the previous page. An injection moulded plastic body with an imprinted texture rather than some applied covering, a film selection dial highlighting six different Kodak named films (Pan X, Plus X, Tri X etc., although I'm not sure what you selected if you had, say, an Ilford or an Agfa film), an exposure button that pushed back towards the camera body (to help alleviate camera shake), and a "weather map" of exposure guides. The whole experience was geared to the users, enabling them to take competent photographs without the need for huge technical know-how. Eastman had once said that he wanted to make cameras for people who wanted to take pictures, not for people who wanted to be photographers.

The example shown here, which was in production from 1959 to 1965, came in a tidy presentation box with an excellently laid out, easy to understand manual. The marketeers got this one right.

A view of the Colorsnap 35 seen from above shows the easy-to-use symbols for the setting of exposure and focus.

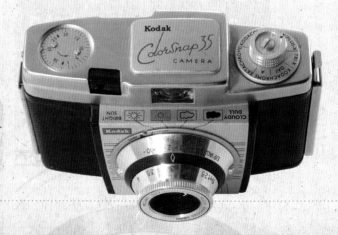

Dimensions:	Country:	Lens:
H **3.15in / 80mm**	**UK**	**Anaston**
W **5.1in / 130mm**		Film:
L **2.6in / 65mm**		**35mm**

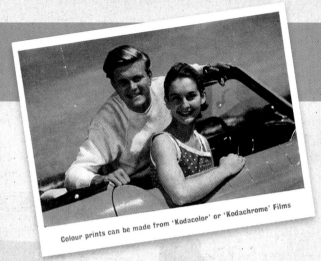

Colour prints can be made from 'Kodacolor' or 'Kodachrome' Films

Left and Below:
The instruction book provided detailed explanations of the Colorsnap 35's settings and controls.

Above: *Publicity emphasized the benefits of Kodak films.*

Below: *The Colorsnap 35 was sold as a neatly packaged outfit.*

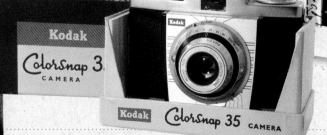

IDENTIFICATION OF CONTROL

1 Exposure counter
2 Shutter button
3 Notch
4 Viewfinder
5 White diamond
6 Re-wind knob
7 Sliding latch
8 Distance ring
9 Film-speed setting scale
10 Serrated tongue
11 Light-setting ring
12 Weather conditions
13 Lever wind
14 Shutter re-set lever
15 Film-speed reminder disc
16 Opening pin
17 Flasholder socket
18 Lock button
(Re-wind button and tripod bush on underside of camera)

5

Chapter 3
1960–1969

The 1960s continued where the previous decade left off—with heaps of new ideas, from flawless Swiss engineering to miniature spy cameras, and plastic toy oddities to best-selling innovations. The greatest change during this decade was the progressive seizure of the world photographic-equipment market from the German companies by the Japanese manufacturers. Before 1960, the Japanese were emulating and sometimes copying German designs; after 1960, German manufacturers struggled to keep up with Japanese optical and technological innovation and advanced manufacturing techniques.

Meanwhile, the USA impressed the world with some clever developments, the Russians arrived with more German clones, the British manufacturers were disappearing fast, and just around the corner was the inexorable advance of the Rising Sun.

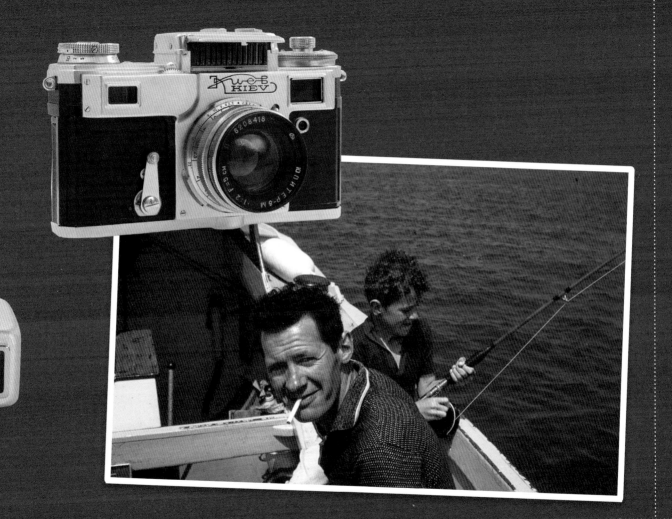

Agfa
FLEXILETTE 1960

A uniquely styled hybrid camera that suffered from an identity crisis, the Agfa Flexilette stands out as an eye-catching oddity. The 1960 model was the first 35mm twin-lens reflex to be marketed since the Zeiss Ikon twin-lens Contaflex of 1935. It appeared in Britain as the ending of import controls opened the British market to Japanese cameras, notably, at the beginning of the 1960s, to single-lens reflex (SLR) cameras from Nikon, Pentax, Minolta, and then Canon. Its eye-level pentaprism viewfinders enabled users to focus a right-way-round image from the taking lens on a focusing screen, whereas the waist-level viewfinder of the Flexilette, like any twin-lens reflex, provided a focusing image that was reversed left-to-right by a viewing lens positioned slightly above the taking lens.

The trend for the new SLR cameras made it difficult for the Flexilette to compete. As to be expected from a German manufacturer of the time, it was a well-engineered product, with its waist-level viewfinder containing a "sports" finder that popped up with the slide of a button. It used 35mm film and the winder was located on the underside of the camera body, unlike most contemporary designs, possibly because there was not enough room on top. The winder had a long rotation, was fiddly to use, and the whole camera was ergonomically inept compared to other SLRs of the time, and didn't have interchangeable lenses.

Note the fun illustrations in the instruction manual.

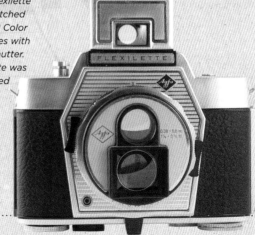

The Agfa Flexilette had two matched 45mm f/2.8 Color Apotar lenses with a Prontor shutter. The Flexilette was also marketed as the Agfa Reflex.

FLEXILETTE
3030

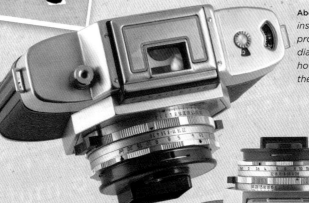

Above: *The instruction book provides detailed diagrams showing how to load the Flexilette.*

Above: *The Flexilette instruction book included some entertaining drawings showing practical ways of using a twin-lens reflex.*

Right: *Top of the Flexilette with viewfinder hood folded, showing the sports finder, and open showing the focusing screen.*

Kodak
BROWNIE STARMITE 1960

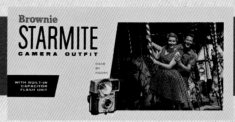

Yet another gem from Kodak, this great little camera— basic and simple, of course—must have filled many a Christmas stocking back in the 1960s. Sold only as an "outfit" containing the camera, flashguard and bulbs, a battery, and two Verichrome 127 films, I wonder how many youngsters were inspired to take up photography in later life as a result of having one of these?

Certainly, all the enthusiasts that I've ever met had a camera plonked into their hands at an early age. The Starmite produced 12 4 × 4cm images on 127 film, color or black and white, and therefore, offered the choice between color or black-and-white prints or Superslide transparencies. Film was loaded through the underside of the camera that was mainly plastic in construction. It had a good lens, a large viewfinder, a double-exposure prevention feature and—with its built-in flash—was ready for action indoors or out. It is interesting to note that the flashbulb manufacturer, Sylvania, showed a picture of the Starmite on its packaging.

The camera could be set for color photography (with slower film speed, and therefore, a larger aperture) by sliding the switch under the lens to between 13 and 14. The other setting accommodated the faster black-and-white film speeds. The Starmite sold for $12 from 1960 to 1963 (or £4.4s.0d in the UK, which was about 20% of the average weekly wage). A second version was available up to 1967.

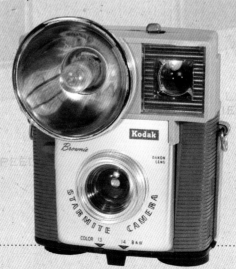

The Starmite ready for action with an AG1 flashbulb inserted.

Dimensions:	Country:	Lens:
H 4.3in / 110mm	USA	Dakor
W 3.4in / 85mm		Film:
L 2in / 50mm		127

SYLVANIA FLASHBULBS

BLUE DOT

AG1B

TWELVE BLUE BULBS

Right: *Detailed instructions for the use and care of the flash unit on the Starmite were given in the camera instruction book.*

Left: *Flashbulb packaging showing the camera.*

Below Left: *The camera base showing the keys to open it for loading.*

Below Right: *The back view showing the rear-view viewfinder.*

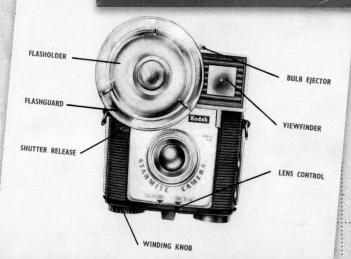

BROWNIE STARMITE Camera

BATTERY · CAPACITOR MODEL

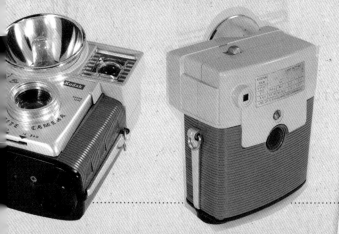

FLASHOLDER

FLASHGUARD

SHUTTER RELEASE

BULB EJECTOR

VIEWFINDER

LENS CONTROL

WINDING KNOB

Minolta
16 II 1960

Released in 1960, this updated second version of the Minolta 16 embodied a confidence in design and technology that even professional photographers were taking seriously. Minolta had a bit of a head start with research and developments when it purchased the camera wing of Konan (a Japanese research institute that developed cameras in the late 1940s and is still working in the field of ultrasound imaging), and improved its original Konan 16 design.

Minolta's success with its Minolta 16 sub-miniatures, allied with the great popularity of the Minolta SR series of 35mm SLRs, marked the company out as a world-class manufacturer and coincided with the development of better negative films with much improved, finer grain and excellent image sharpness. The camera was hugely popular and later appeared in a variety of bright, metallic colors (it was a kind of iPod of its day). The Minolta 16 sub-miniatures used a new cassette, introduced in 1956, giving tiny negatives of 10 × 14mm on 16mm film and sold for £16 (approx. $44.65) in the UK, which was just under the average weekly wage in 1960. Bizarrely, there was even a version sold (under a different brand name) with a built-in transistor radio. Allegedly, one of these was sneaked into Elvis' funeral and was used to take a photo of him in his casket.

! hints for beginners....

HOLDING THE

Hold camera either horizontally or vertica brow. The important thing is to hold the c at the moment' you press the release but your finger on the release. Instead, squee

Dimensions:	Country:	Lens:
H 1in / 25mm	Japan	Rokkor 1:28mm
W 3.9in / 100mm		Film:
L 1.8in / 45mm		16mm

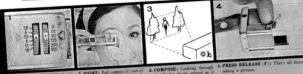

If you know nothing about cameras···

1. **SET F-STOP; SET SPEED:** Set the lens openings (A) and shutter speed (B) as shown on the exposure table enclosed with each roll of film···by rolling red dot on wheel opposite desired speed and opening.

2. **SIGHT:** Pull camera (C) out of built-in case (D) as far as it will go and look through viewfinder (E).

3. **COMPOSE:** Looking through viewfinder, shows subject as it will appear on film. Keep camera at least 6 feet from subject.

4. **PRESS RELEASE (F):** That's all there is to taking a picture.

Far Left: *Detailed instructions for novices.*

Left and Below: *Advertisements from the* British Journal of Photography *almanac, 1961.*

Far Left: *The Minolta 16 Model II had an f/2.8 Rokkor lens and a five-speed shutter from 1/30 to 1/500. It was sold with three supplementary lenses, one negative to give infinity focus, and two positive for close-ups.*

Below: *Original presentation box.*

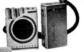

THE BRITISH JOURNAL ALMANAC (1961) ADVERTISEMENTS

The camera that hides in your hand.

16-II

Lens : f 2.8 – 22 mm Coated Rokkor lens.
Shutter : B. 1/30 to 1/500 sec. Click-stop settings.

576 THE BRITISH JOURNAL ALMANAC (1961) ADVERTISEMENTS

Minolta
means *better picture*

camera of quality made with our 30 years' experience.

Manufactured by
CHIYODA KOGAKU SEIKO K.K. Osaka, Japan
Agent in England :
Japanese Cameras Ltd. 50 Piccadilly, Tunstall, Stoke-on-Trent.
Agent in Ireland :
F. Barrett & Co., Ltd. 34 Anne's Lane, Dublin.

World Famous Minolta 16 II
The push-pull camera...your constant companion

PULL Automatically advances film and frame counter. Cocks shutter, speeds up to 1/500th second.

SNAP Easy to use, always handy, get those pictures normally missed. Razor sharp F/2.8 Rokkor lens.

PUSH Closes to just 3¼". Weighs less than 6 oz. Carry in pocket or purse.

Voigtländer
VITO CLR 1960

Johann Voigtländer created his company, a manufacturer of optical instruments, in Vienna in 1756, making it the oldest photographic company in the world. His first successes were measuring instruments and opera binoculars, but by 1840, the company had produced the fastest lens of the time and then, a year later, the first all-metal camera. Always a leader in forward-thinking technological developments, it made the first-ever zoom lens for a still camera in 1960 and the first 35mm compact camera with a built-in flash in 1965.

The Vito CLR was a robust, precision-made rangefinder camera with extremely reliable optical and mechanical parts, as to be expected from a company that had developed a significant reputation from producing lenses in the nineteenth century. There were 12 variants of the Vito-C series cameras made before Zeiss Voigtländer went out of business, each with only slight visual differences, but all made with the same beautifully smooth body and classy metal finish. Most of the earlier versions had the distinctive rounded tops. Typical German excellence shone throughout; even the instruction booklet is nicely put together, and the example shown here is the Deluxe model, from 1960, which had the exposure meter needle visible both

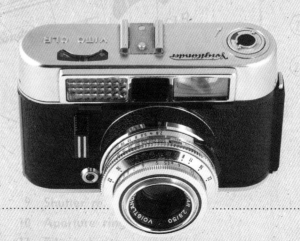

Left: *Voigtländer was famous for the quality of its instruction books.*

Right: *The Voigtländer CLR De Luxe, with shutter release on the front of the camera.*

88

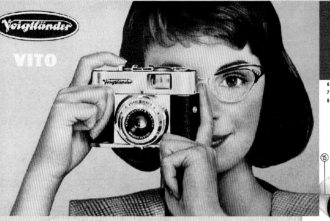

Voigtländer

VITO

Dimensions:	Country:	Lens:
H 3.4in / 85mm	Germany	Color-Skopar
W 5.1in / 130mm		50mm f/2.8–f/22
L 3in / 75mm		Film:
		35mm

6 Depth of field scale	18 Self-timer tensioning lever
7 Shutter speed ring	19 Film counter with setting button
8 Shutter speed scale	20 Tripod bush

All brands of films in the market can be used in the VITO CLR. The daylight cassettes with the perforated 35 mm film give 36 or 20 frames, resp., 24 x 36 mm — no matter whether black-and-white or colour negative or colour reversal film.

Illustration II

Illustration

in the viewfinder and on top of the camera, instead of just on top. This might explain its price tag of £43.5s.0d (approx. $120.70), which was rather more than twice the average weekly wage in 1960 of £18.5s.0d (approx. $50.93).

Above: *The extremely detailed Vito CLR instruction book.*

Above Left: *The Vito C range brochure.*

Below: *The top of the camera showing the meter read-out.*

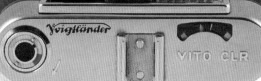

Clean the lens only with a so
particles of grit (or sand at
Finger marks and other trace
with a piece of cotton wool

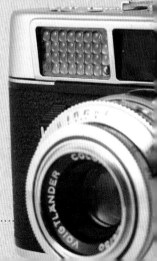

Kiev
KIEV 4 1961

Soviet progress in camera design and development relied heavily upon "acquisitions" of German machinery, tooling, and spares from Zeiss Ikon in Dresden, and Carl Zeiss in Jena, that were shipped back to the Soviet Union under the guise of war reparations after the Second World War. Manufactured in the converted arsenal at Kiev, over a million of these Contax clones (remove the Kiev badge from the earlier models and there Contax was etched underneath) were mass-produced for the best part of 40 years.

It could be argued that this "industrial espionage" approach, coupled with a state system that didn't encourage competition in technology development, but favored quantity over quality, hampered the progress of camera design in the USSR so that it fell behind that of the West. The Kiev 4 was a development of the pre-war Contax III 35mm coupled rangefinder camera, with a built-in selenium-cell exposure meter on top with a flip-up door on the front. A range of Soviet-made 28mm, 35mm, 50mm, 85mm, and 135mm lenses based on Carl Zeiss' designs was available, and the Kiev cameras also accepted pre- and post-war Carl Zeiss lenses made for German Contax. The model shown here has a serial number starting with 61, giving its year of manufacture as the same that Russia won the space race, putting Yuri Gagarin into orbit, as celebrated on the stamp opposite. (I wonder whose technology was in that rocket?)

The Kiev IV with 50mm f/2 Jupiter lens, developed from the Carl Zeiss Sonnar. The exposure meter was graduated in the Soviet GOST film speed system.

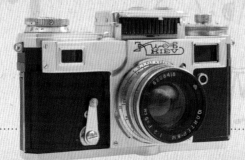

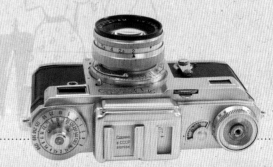

Dimensions:	Country:	Lens:
H 3.55in / 90mm	**Russia**	1:2 50mm
W 5.5in / 140mm		Film:
L 2.5in / 62mm		35mm

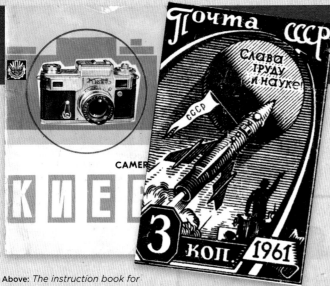

Above: The instruction book for the Kiev 4—note its name in Cyrillic characters.

The Kiev 4 appeared in 1961 with a UK price of £59.15s.0d (approx. $166.74), more than three times the average weekly wage of £19.7s.0d (approx. $54).

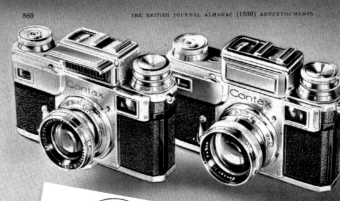

Above: *Original Zeiss Ikon Contax III as illustrated in* the British Journal of Photography *almanac, 1939— spot the similarity!*

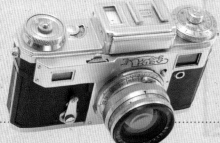

Above Right: *Commemorative Sputnik stamp.*

Left: *The Kiev 4, made in the Arsenal factory in Kiev.*

Unknown
EMPIRE BABY 1961

It is indeed a wonder that any of these were ever sold—there are no identifying marks to tell us who the manufacturer was, other than the "made in Hong Kong" information on the instructions, box, and wind-on dial. Well, let's face it, if you had made it, wouldn't you want to remain anonymous? In the same year (1961) that the American physicist Theodore Maiman perfected the laser, someone in Asia gave us this beauty, the Empire Baby.

Categorized under "toy cameras" it shot up to 16 33 × 28mm images on 127 film and opened up like a clam as it was hinged on one side—although the whole back unclips to give you two halves. The Optical Crystal lens was of a slightly higher quality than the rest of the camera. Researching the UK design registration number 890884 reveals that it was possibly made in Macao, China. The name must be a derivation of the phrase "Empire Made," which referred to low-cost, low-quality products of the now-defunct British Empire that were manufactured in Hong Kong. This camera is totally retro low-brow—fabulous!

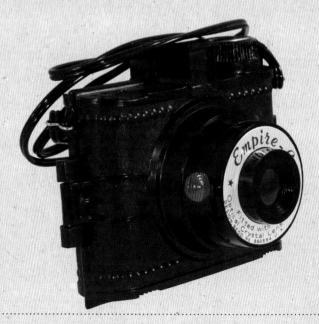

The Empire Baby was cheap and made a lot of people very cheerful.

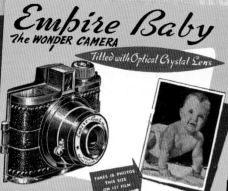

Empire Baby
The WONDER CAMERA

Fitted with Optical Crystal Lens

TAKES 16 PHOTOS THIS SIZE ON 127 FILM

Dimensions:	Country:	Lens:
H 3.55in / 90mm	Hong Kong	Single element
W 2.75in / 70mm		Film
L 2.1in / 52mm		127

Above: *The instruction leaflet promises much.*

Right: *The "dos and don'ts leaflet" makes clear that the rudimentary lens is set for a hyperfocal distance of about seven feet from the camera.*

Below: *The top and front views of the Empire Baby.*

HELPFUL HINTS FOR BETTER PICTURES

DO'S
- Clean lens before taking pictures
- Always have the sun *behind* you
- Hold camera steady against your face
- Press *down* shutter release gently
- Use the view finder to its full limits . . . the camera actually sees more than you do

DON'TS
- Load or unload film in a bright area
- Snap pictures when there is no sun
- Snap pictures in the shade
- Take pictures closer than 5 feet

1 2 3 4 5 6 7 8 9 10

You'll take your best pictures when subject is 5 to 10 feet from you

FUN IN THE SUN
with your new
WONDER CAMERA

TAKES 16 PICTURES ON STANDARD 127 FILM

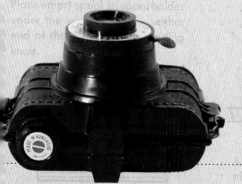

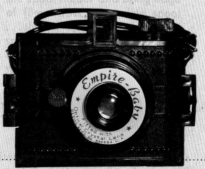

Kodak
BROWNIE SUPER 27 1961

With quirky space-age styling, this unusual offering from Kodak looks more like a portable radio than a camera. As with all things American from this period (cars, buildings, cigars) everything was bigger and brasher, and the Super 27 is no exception, with even the name implying "supersize."

Surely aimed at the most inexperienced amateur, the Super was not particularly ergonomic, with its boxy feel, ultra lightweight plastic construction, and BIG buttons and dials. You just have to smile at the "CL'DY, BR'T, SUNNY" dial—surely they had enough room to spell the words out in

full?—and the two lens-setting options, for "close-ups" and "beyond 6ft." Then there's the hidden flash holder for AG1 flashbulbs behind the door beside the lens, spring-loaded to hold it open against the wind and protect the flashbulb. The act of turning the film winder cocks the camera and the big shutter button resounds with a big, reassuring clunk. A stylish presentation box completes the package. This simple, gorgeous camera, which shot 12 pictures on 127 film, had a production run between 1961 and 1965 and cost $19 when released, which was the equivalent of £4.15s.0d in the UK, about a quarter of the average weekly wage.

A quite different design to other post-war Kodak Brownies, the Super 27 was light yet reassuringly solid.

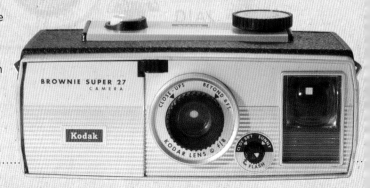

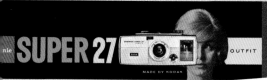

Dimensions:	Country:	Lens:
H 2.1in / 70mm	USA	Kodar f/8
W 5.9in / 150mm		Film:
L 2.1in / 70mm		127

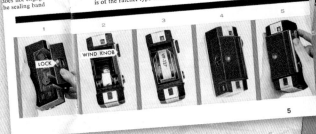

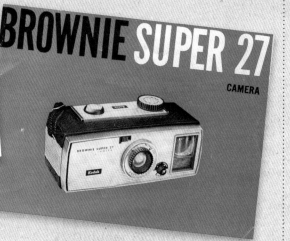

Above: *The instructions for loading the Super 27 are detailed.*

Below: *The back view of the Brownie Super 27 shows the red window for seeing the exposure number when you wind on.*

Right: *In the attractive blue instruction leaflet.*

Below Far Right: *Flash compartment under flap.*

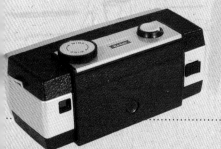

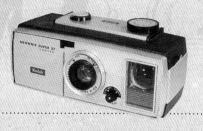

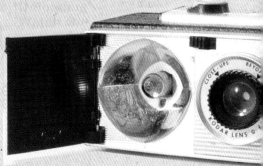

Ilford
SPRITE 127 1962

This was one of those finds that just comes along now and then—a complete presentation box containing camera, films, case, and instructions, plus the "selected for the Design Centre" tag.

Agilux, the Croydon-based company that brought us the Agiflash (see pages 48–49) made this camera for Ilford, the film manufacturer in 1962, and later made the Pixie, the Imp, and the Sprite 35—some sort of hobgoblin series, perhaps? It was constructed in light gray plastic and had a single shutter speed with two settings for the lens aperture, depending on what film (color or black and white) was being used. As seen before on Kodak's Starmite (see pages 84–85), the aperture settings differed because of the slower speeds of color film, which therefore needed more light passing through the lens. With 12 square 4 × 4cm images per roll of 127 film and costing £1.3s.6d (approx. $3.28), the Sprite was an affordable item in the UK, where the average weekly wage in 1962 was £20.1s.0d (approx. $55.95). As a kid I saw these types of cameras piled up literally from floor to ceiling in kiosks at beach-side resorts—they were squarely aimed at holidaymakers. This set must have been very attractive, with everything the user needed to capture the sand-and-sunscreen action on the beach. This might also explain the sun motif on the packaging.

Ilford was primarily a manufacturer of film and photographic materials, and like Kodak, tried to build loyalty for Ilford film by selling Ilford cameras.

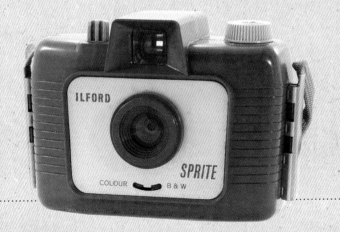

Dimensions:	Country:	Lens:
H 3in / 75mm	UK	Plastic, fixed focus
W 4.3in / 110mm		Film:
L 2in / 50mm		127

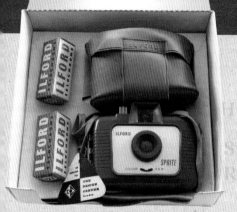

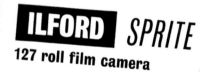

THE DESIGN CENTRE is an exhibition of well-designed British goods in current production, selected by the **COUNCIL OF INDUSTRIAL DESIGN**

Above: Design Centre endorsement.

Above: Original presentation box.

Below: The chunky curved lines of the Sprite are clear in this top view.

Left and Below: The instruction leaflet for the Sprite shows clearly how to load and use the camera.

ILFORD *SPRITE*
127 roll film camera

...rd ...n. ...ull ...pty spool is in the winding side of the camera. If not, transfer it as explained under "Unloading your Ilford Sprite."

Now insert a new film in the spool chamber. Push it first against the hook-shaped spring, then slip the top into position. Break the sealing band and with

Canon
CANONFLEX RM 1962

Single-lens reflex cameras (SLRs) were not fully accepted as practical cameras by most enthusiasts until the advent of instant-return mirrors and automatic diaphragms in the 1950s and early 1960s. The Canonflex RM of 1962 was Canon's fourth Canonflex model and the first without an interchangeable prism. Like the other Canonflex models, it used interchangeable Canon R lenses with automatic diaphragms, but unlike the other models, it had a built-in selenium-cell exposure meter, which meant that the camera could be set without the hassle of using a handheld meter. In the instruction booklet for this model the opening page concluded with this typically Japanese entreaty: "We look forward to your making full and effective use of the Canon camera in your home, in your research laboratory, on trips, and on hikes."

The Canonflex RM had its lever-wind at the top of the camera instead of at the bottom, so that it could be easily wound with the thumb while at eye level, and had an easily seen exposure-meter window on the top plate.

The *British Journal of Photography* noted in its 1963 review that the "Canon RM is a modern precision instrument of very careful design with interesting innovations which should make for great efficiency." It gave the price of the camera (with 50mm *f*/1.8 lens, as seen here), as in excess of £122 (approx. $340.46), more than six times the average weekly wage in 1962. Made in Japan and released in 1962, it was curiously advertised as the "Single Eye Reflex Camera" as opposed to SLR. (Could there be something lost in translation, perhaps?)

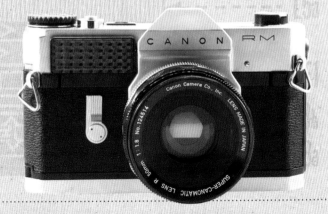

Dimensions:	Country:	Lens:
H 3.55in / 90mm	Japan	50mm 1:1.8
W 5.9in / 150mm		f/1.8–f/16
L 3.55in / 90mm		Film:
		35mm

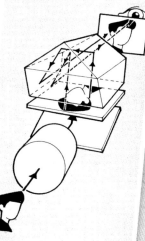

Left: *Illustration from The Canon Reflex Way by L. Gaunt, 1979, by Focal Press.*

Right: *An advertisement for the Canon Range in 1963 by J.J. Silber, then the UK importer of Canon equipment.*

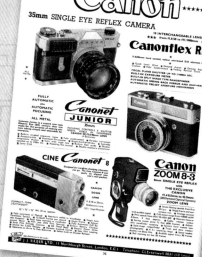

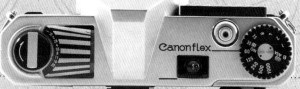

Left: *The styling of the RM was rather slick and stylish.*

Left: *The uncluttered top plate of the Canonflex RM, fitted with 50mm f/1.8 Canon R lens in a breechlock mount, seen from above.*

Far Left: *The optical path of light from the subject (bottom of diagram) to the photographer's eye, via lens, mirror, focusing screen, pentaprism, and viewfinder lens.*

Bolex
P2 1963

Jacques Bolsky, an engineer studying and living in Switzerland, designed his first camera in 1923, the Cinegraph Bol—a 35mm camera capable of taking stills or moving action that could also be used as a film projector. His first 16mm movie camera was introduced in 1928 under the name Bolex five years after Kodak brought out the new smaller format as a cheaper alternative aimed at amateur film makers. The rights to the Bolex design was sold in 1931 to Paillard when Bolsky left Geneva to live in the USA, the year before Kodak took another leap forwards with the Standard 8mm film, a spooled film format that remained the domestic norm for over 30 years.

Although the audio cassette was invented in 1962, it took a few more years for film manufacturers to apply the idea to cine cameras when Kodak (yet again) introduced its easy to load Super-8 cartridge system. The P series cameras, introduced in 1961 with the P1, ending with the P4 in 1965, set a very high standard for precision that remains unmatched to this day.

The main example here, the Paillard Bolex P2, was made in Switzerland from 1963 and cost a stiff £165 (approx. $460.46), roughly eight times the UK average weekly wage of £20.17s.0d (approx. $58.19).

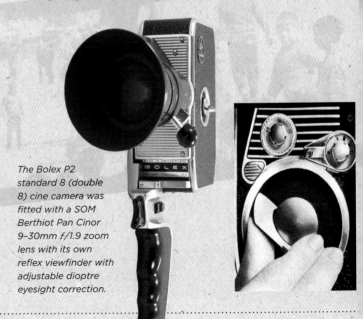

The Bolex P2 standard 8 (double 8) cine camera was fitted with a SOM Berthiot Pan Cinor 9-30mm f/1.9 zoom lens with its own reflex viewfinder with adjustable dioptre eyesight correction.

Dimensions:	Country!	Lens:
H 9.05in/230mm	Switzerland	Pan-Cinor 1:1.9
W 2in / 50mm		f/1.9–f/16
L 9.45in/240mm		Film:
		8mm

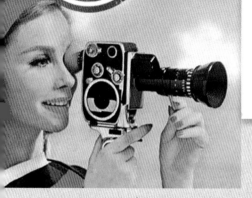

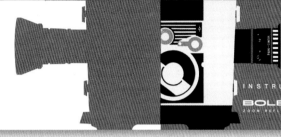

Below: *A 1939* British Journal of Photography *almanac advertisement for the 16mm Bolex H16 movie camera, made in successive versions through to the 1970s.*

Above: *The instruction leaflet for the later Bolex P4 of 1965, another Standard 8 camera; but by then with a built-in SOM Berthiot Pan Cinor 9–36mm f/1.9 zoom lens.*

Above: *Framing the shot by using the zoom lever while looking through the reflex viewfinder on the zoom lens.*

Below Left: *The clockwork winder.*

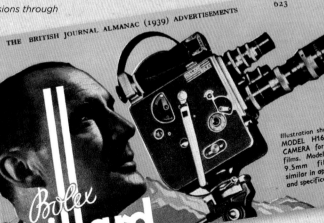

Cine-Vue
8MM FILM VIEWER 1960s

So, once you had shot and developed your precious home movie, how could you get to see it without rigging up that chunky film projector plus annoyingly cumbersome screen in a dark room? Cue Cine-Vue, the handy pocket-sized plastic movie viewer. Bright, funky pink packaging would draw your attention to this gem of ingenuity.

Costing about one hundreth of the price of the Bolex cine camera on the previous page, this sturdy piece of plastic was the portable answer to getting a sneak preview. A well-thought-out instruction insert came with a great disclaimer: "You can only view a well-defined picture if the definition of the image on the viewed film is correspondingly sharp." At first, the mysteriously asian cartoon illustration on the side of the box suggests that this might have originated in China, but it's definitely a made-in-England item with box notes that proudly claim

The Cine-Vue hand-cranked viewer was for Standard 8 film, not the later Super 8, which has smaller perforations.

"Nylon gate, claw and spindle, excellent animation, easy to load and operate, no screen, electric or battery supply needed. Load with a 50ft film and see your 8mm films in fast or slow motion or as still brilliant and well-defined pictures. Rewinds without unloading. Handles film with great care."

This item was sold in the UK by the Brighton-based company Cine Accessories Ltd. from 1958.

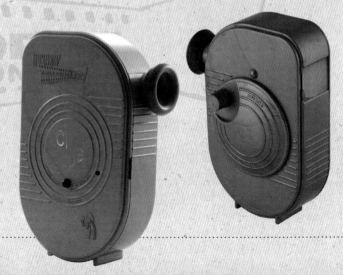

Dimensions:	Country:	Film:
H 5.5in / 140mm	UK	8mm
W 5.3in / 135mm		
L 3.9in / 100mm		

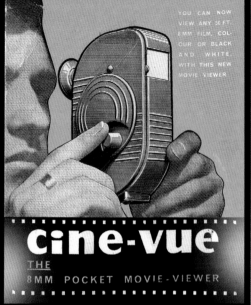

Below: *Standard 8 film was threaded through the Cine Vue in much the same way as through a Standard 8 camera. The insert card showed how it was done.*

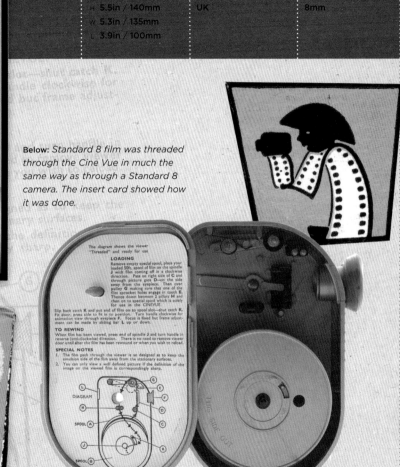

Above: *The film was viewed by natural daylight transmitted by the rectangle of white translucent plastic in the line of sight from the eyepiece.*

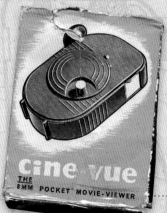

The diagram shows the viewer "Threaded" and ready for use

LOADING
Remove empty special spool, place your loaded 50ft. spool of film on the spindle **J** with film coming off in a clockwise direction. Pass on right side of **C** and through picture gate **D**—on the side away from the eyepiece. Then over pulley **G** making sure that one of the film sprocket holes engage in tooth **E**. Thence down between 2 pillars **H** and then on to special spool which is solely for use in the CINEVUE.

Slip back catch **K** and put end of film on to spool slot—shut catch **K**. Fit door, press side to fit in to position. Turn handle clockwise for animation view through eyepiece **F**. Focus is fixed but frame adjustment can be made by sliding bar **L** up or down.

TO REWIND
When film has been viewed, press end of spindle **J** and turn handle in reverse (anti-clockwise) direction. There is no need to remove viewer door until after the film has been rewound or when you wish to reload.

SPECIAL NOTES
1. The film path through the viewer is so designed as to keep the emulsion side of the film away from the stationary surfaces.
2. You can only view a well-defined picture if the definition of the image on the viewed film is correspondingly sharp.

LOMO
SMENA-8 1963

The Beatles hit the big time in 1963 with their hit "Please Please Me," and in the USSR, that's just what LOMO were doing with the Smena-8, a hugely popular camera that was part of a series of Smena cameras stretching back to 1939. Depending on which website you read, LOMO—the Leningrad Optical Mechanical Union (or Amalgamation, or Enterprise)—was founded in 1914 to produce lenses and cameras.

For nearly a century, it has been doing just that, and more, and today, it produces military optics, research and medical equipment, and products for the motion-picture industry. A post on www.sovietcams.com suggests that the Smena-8 and later the 8m (see pages 156–157) sold over 21 million units and there were certainly many variations produced by LOMO, GOMZ, and LOOMP in similar styles. The slightly raised left-hand

side of the camera made it easier to hold and was an ergonomic departure from the generally smoother cameras of the period. The lens quality was pretty good, but had a cheap plastic body construction prone to light-leakage. Shown here is the home-grown version— the export models appeared with the Roman characters for "Smena" or were rebranded the "Cosmic 35" with bright, minimal box-art that seemed to pay homage to the constructivist art movement of the 1920s.

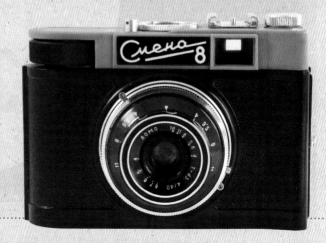

The Smena 8, made in the former Gomz factory in Leningrad, had a 40mm f/4 lens and shutter speeds from 1/15 to 1/250 and B.

Dimensions:	Country:	Lens:
H 3in / 80mm	Russia	f/4–f/16
W 4.5in / 120mm		Film:
L 2.25in / 60mm		35mm

Left: *The instruction booklet was brightly colored and easy to understand.*

Below: *The handle at the left-hand end of the camera is clearly visible in this high-angle shot.*

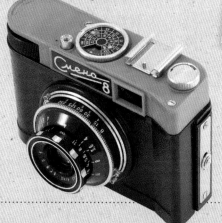

Below: *The Smena 8 has a film type reminder on the top of the camera and is easy to load.*

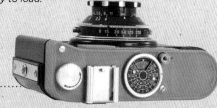

Gevaert
GEVALUX 144 1965

Housed in its garish, tacky vinyl carry case, this camera seemed to fit in with the zany world of Gevaert in 1965. The lady in the advert looks as if she's waiting for her hairstyle to be rescued by Thunderbirds (of the Gerry Anderson variety) and the camera itself could have popped straight out of the prop department. Gevaert of Belgium were manufacturers of film and photographic materials, and marketed various inexpensive cameras during the 1950s. After its merger with Agfa in 1964, this US-made gray-and-brown plastic camera, a rebadged Ansco Cadet, previously marketed in Europe by Agfa, appeared as the Gevalux 144.

It was a bit of an oddity, with its left-handed shutter button and clip-on flash unit and was probably one of the last 127 format point-and-shoots to be produced now that the fashion was for the newer Instamatic types—with Kodak, as usual, catching everyone by surprise (see pages 108–109)—but it certainly looked unique. Once again, as seen in some of the earlier Kodaks, the camera had just two settings for the lens (f/11 and f/16, depending on whether you were using color or black-and-white film) and had a generally "toy" appearance. The big chunky knobs and catches and the false-exposure meter under the shutter button emulated more expensive cameras that actually had such meters.

Made in the USA, the Gevaert 144 used 127 film and had the look of a child's toy, but was an effective snapshot camera.

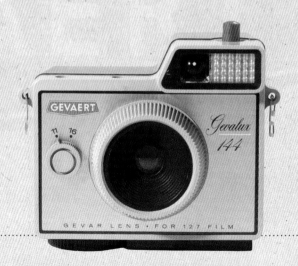

Dimensions:	Country	Lens:
H 3.9in / 100mm	**USA**	**Gevar**
W 3.9in / 100mm		Film:
L 2.6in / 65mm		**127**

Left: *The Gevalux vinyl carrying case.*

Right: *The film-wind knob and the catch to open the camera back are on the base.*

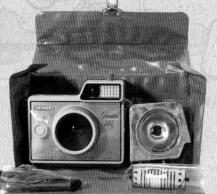

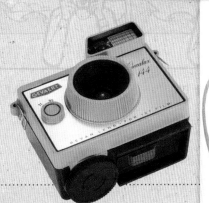

Kodak
INSTAMATIC 104 1965

This was the big one. The tiny **Kodak Instamatic** cameras that used 126 cartridge film broke all records and became one of the biggest-selling series of all time. More than an estimated 60 million instamatics were sold (there were dozens of models), mainly in the 1960s and 1970s with a few models brought out in the 1980s. What made it so popular was Kodak's revolutionary 126 film cartridge that just snapped into place, ridding the photographic world of the accidentally ruined film when the camera was unexpectedly opened in daylight, because with the instamatic the photographer could only lose one frame to fogging, as opposed to many.

Kodak developed this product in response to consumer complaints about the difficulties for the amateur in loading the more common roll films and 35mm cassettes. The cartridge could only go in one way round and there was no need for rewinding—simple. This model, the 104, featured the newly invented flashcube—an improvement on the old single flashbulb. This was automatically rotated 90° to bring the next bulb into position by winding on for another exposure, before being ejected by pressing the button on the top of the body.

When launched in 1965, the Instamatic 104 was $15.95 in USA, roughly £5.13s.0d at the exchange rate of $2.80/£. Average UK weekly pay 1965 was £24.1s.0d.

Instamatic cartridges produced images 26.5mm square and prints from Instamatic negatives were usually 4" square to fit into albums deigned for 6"x 4" prints.

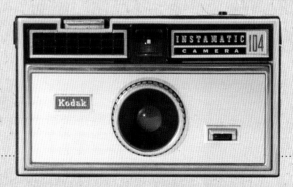

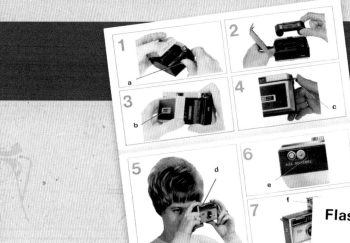

Dimensions:	Country:	Lens:
H 2.4in / 60mm	USA	Ektanar f/2.8
W 3.9in / 100mm		38mm
L 2in / 50mm		Film:
		126

Kodak
Instamatic
Camera

104

See illustrations on front flap

ENGLISH

Right: *The Instamatic 104 was a basic model for flashcubes, made in vast numbers in USA, Canada, England, Germany, and also Australia.*

Flash Facts

NOW YOU CAN TAKE PICTURES BY FLASH

IT'S FUN... AND SO EASY

With your new 'Kodak' Camera, taking indoor flash pictures is as easy as taking snapshots outdoors—and how it adds to the fun! Parties, Christenings, Birthdays, Receptions—there's no end to flash picture possibilities . . . in colour or black-and-white.

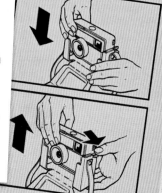

Above: *Flashcube information sheet.*

Left: *An Instamatic 104 with a flashcube in position. This provided four successive flash exposures.*

Right: *Instructions for removing the Instamatic 104 from its case before loading.*

Kodak

Polaroid
SWINGER 20 1965

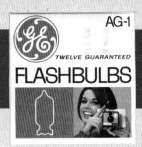

The cultural revolution of the mid-1960s was underway and the younger generation had their own memorable slang, using a thumbs-up sign for "swinging" or a thumb down for "uncool." The Swinging Sixties were picking up steam and what better way to record the fun than to have an appropriately named instant camera with psychedelic-colored packaging and big, bold plastic contours?

The marketing pushed all the buttons with the young and even had Barry Manilow singing the jingle for the TV ad. I'm not sure if it was called the "20" because of its sub $20 price tag or the fact that it used the new Polaroid 20-series roll film (the first to develop "before

your very eyes" outside the camera). It had a built-in flash, a "Yes" display to indicate that the exposure was set correctly and even though it only shot black-and-white pictures, it still shifted four million units in two years, and was produced in the USA from 1965 to 1970.

Corporate marketing being what it was back then, (think Madison Avenue advertising executives), Polaroid had a commercial tie-in with General Electric as the GE flashbulb packaging came with an image of the Swinger on the box.

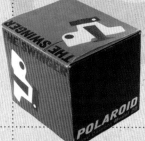

The Polaroid Swinger Model 20 came in an attractive box (left) and had all the attributes of a box camera: a non-focusable meniscus lens (Polaroid 100mm f/17) and a simple rotary single-speed shutter (1/200 second). But it produced instant pictures that developed before your eyes.

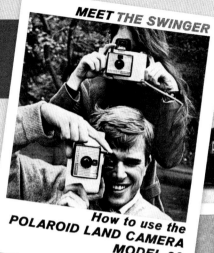

MEET THE SWINGER

How to use the POLAROID LAND CAMERA MODEL 20

Dimensions:	Country:	Lens:
H 4.9in / 125mm	USA	Meniscus
W 5.9in / 150mm		Film:
L 4.9in / 125mm		Polaroid

HOW TO USE POLACOLOR PRINT MOUNTS

COVERED AREA ADHESIVE SURFACE

▲ ALIGN

1. Peel this brown paper back and fold along the dotted line (thus partially exposing adhesive surface). Covered area permits alignment without sticking.

2. Align picture carefully along the top long edge pressing only lightly to the adhesive end until there is perfect alignment.

3. Now press picture down firmly along right edge where adhesive is exposed. Remove brown paper by pulling down on tab (A in drawing). Press picture to mount working along two long edges from right to left.

F3122 "Polacolor" 5. Printed in U.S.A.

START TO PEEL ALONG EITHER OF THESE EDGES

Above: *The Swinger 20 was truly easy to use, and the instructions were excellent.*

Below: *The view from above shows the very long viewfinder.*

Above: *Instructions on how to use self-adhesive print mounts.*

Left: *Detailed "how to" images from the instructions.*

Below: *Detail showing print mounting.*

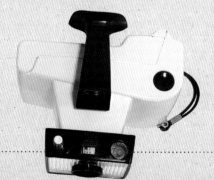

Yashica
LYNX 5000E 1966

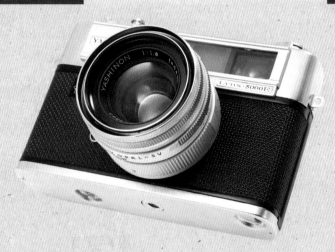

YASHICA

The Yashica Lynx series of coupled-rangefinder cameras with built-in exposure meters began in 1960 with the Yashica Lynx 1000, notable as one of the very few camera models offering a shutter speed of 1/1000 second from a between-lens shutter. The Lynx 14 of 1965 had a CdS exposure meter instead of the selenium meter, and notably an *f*/1.4 lens, almost unheard of in a non-interchangeable-lens camera. This Yashica Lynx 5000E appeared in 1966, and with the 1960 Lynx 14E IC of 1969, was among the earliest cameras to use integrated-circuit technology. The name Yashica was a contraction of Yashima Camera—Yashima engineering expertise had been honed in armaments manufacture, and later, in making components for clock and electrical manufacturers. Yashica made its first cameras in 1953.

By looking through the viewfinder and altering the lens aperture settings you get a red "under" or "over" exposure display rather than the conventional swinging needle. After decades of high-quality camera production, the company was acquired by Kyocera in 1983 and after intense competition from rivals like Minolta and an under-performing Autofocus SLR project, the brand was gradually reformatted as an almost anonymous low-end manufacturer of cameras in Hong Kong—a sad end.

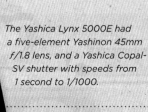

The Yashica Lynx 5000E had a five-element Yashinon 45mm f/1.8 lens, and a Yashica Copal-SV shutter with speeds from 1 second to 1/1000.

FLASH PHOTOGRAPHY

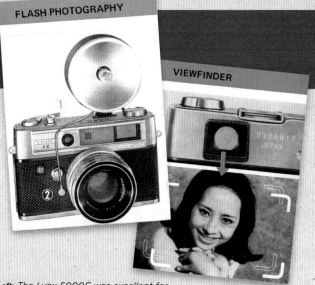

VIEWFINDER

Dimensions:	Country:	Lens:
H 3.4in / 85mm	Japan	1:1.8 f/4.5–f/22
W 5.1in / 130mm		Film:
L 2.85in / 72mm		35mm

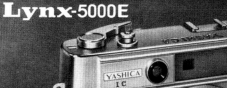

Lynx-5000E

Left: *The Lynx 5000E was excellent for flash photography.*

Above Right: *The camera had a clear Brightline viewfinder and coupled rangefinder.*

Right: *This shot shows the circular CdS meter window in the front of the top plate and the folding rewind crank, then a novel feature.*

Above: *The Lynx 5000E was a handsome, successful camera. In total contrast to our previous plastic Instamatic and Swinger cameras, the Yashica weighs in at a hefty 2lbs.*

Left: *Exposure advice from the instruction manual.*

LIGHTING CONDITIONS		SHUTTER SPEEDS
☀	BRIGHT	$\frac{1}{1000}$ • $\frac{1}{500}$ • $\frac{1}{250}$ sec.
⛅	HAZY	$\frac{1}{250}$ • $\frac{1}{125}$ sec.
☁☂	CLOUDY·RAIN	$\frac{1}{60}$ • $\frac{1}{30}$ sec.
🏠	INDOOR	$\frac{1}{30}$ sec. or slower shutter speeds
▶	SPECIAL	1 sec. • B

KMZ
ZORKI-4 1968

The Zorki 4 was a 35mm coupled-rangefinder camera, manufactured by the Krasnagorsky Mechanical Factory (KMZ) near Moscow. One of a number of different Soviet cameras that emulated Leica cameras by using the Leica 39mm interchangeable screw-lens mount and (approximately) Leica rangefinder coupling, the Zorki 4 resonates with a Russian-ness that's typical of the late 1950s and early 1960s, evoking images of Sputnik, old battleships, espionage, and lantern-jawed KGB officers in trench coats.

The name Zorki translates as "sharp-sighted," which would have been good advice if you were a rival camera maker. But then this is what Russia did so well—make robust, bulletproof cameras that just kept going and were sold, compared to their German counterparts, at

The Zorki 4 has coupled rangefinder, dioptric eyesight correction for the viewfinder (lever under the rewind knob), delay action (lever at lower left front), and full flash synchronization (3mm PC socket under the Z of Zorki). The 50mm f/2 Jupiter 8 lens is a gem.

very low prices. During its long production run from 1956 to 1973, the factory produced an estimated 1.7 million cameras (about 100,000 per year) and dozens of variants. Like most 1960s cameras, the bottom plate is removeable and the film is loaded through the bottom. Many of the details seem old-fashioned because it's based on a 1930s style. This Zorki has the good-quality Jupiter 8 lens fitted that was a direct copy (of course) of the Zeiss Sonnar. Features such as the Roman lettering of the model name, the lack of camera-strap lugs, and the "made in USSR" on the back, date it to 1968.

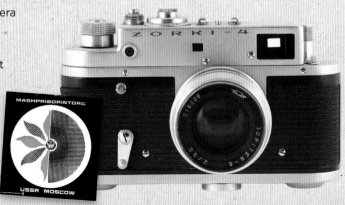

Dimensions:	Country:	Lens:
H 3.55in / 90mm	Russia	Jupiter 50mm f/2-f/22
W 5.5in / 140mm		Film:
L 2.75in / 70mm		35mm

Above: *The instruction book is detailed and helpful. If the camera was originally imported to Britain or USA then it would be in English.*

Right: *The delay action is set by pushing the lever down to six o'clock, and started by pressing the chrome button at twelve o'clock. It should run for about ten seconds.*

Below: *Focus with the second finger of your left hand, fire the shutter with the first finger of your right.*

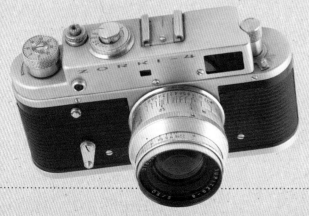

Above: *The shutter speed dial is on top, next to the shutter release. Always wind the camera before changing the shutter speed! There was no hinged back on this model.*

Canon
DIAL 35-2 1968

We end this chapter with this example of an ingenious design classic, a late entry into the popular half-frame market of the 1960s. The Canon Dial 35-2, like other half-frame cameras, shot up to 72 18 × 24mm images on a standard cassette of 35mm film. It was a functionally beautiful Electric Eye (EE) camera, embodying the exuberance and style of the swinging sixties, and was designed for simple, single-handed shooting.

The Dial was certainly economical as it could give the photographer twice as many images from one roll as you were shooting half-frame. With a short, wide-diameter lens barrel containing the metering photocells around a 28mm lens, it resembled the pre-push-button dial telephone. There was a cylindrical handle at the bottom that also wound the clockwork mechanism. Its unique design style—there really has been nothing like it before or since—was attributed to Hiroshi Shinohara who worked at Canon for more than 30 years, eventually heading up its Design Division. Made in Japan, this updated version (there was an earlier joint manufacturing project with Bell & Howell producing the same style camera) was released in 1968.

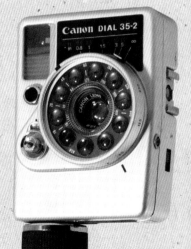

Left: *By 1968, the English of Canon instruction books had become much smoother and more informative.*

Right: *The "handle" of the Canon Dial serves as the winder for the clockwork motor drive.*

Dimensions:	Country:	Lens:
H 5.25in /135mm	Japan	28mm 1:2.8
W 3in / 75mm		Film:
L 1.75in / 43mm		35mm

Left: *The Canon Dial produces half-frame (24mm × 18mm) images on 35mm film. The standard cassette is loaded at the top of the camera and winds to the take-up spool at the bottom.*

Right: *The Dial 35-2 was promoted as an always-ready camera for instant action.*

Below: *Winding the motor drive. The exposure counter is beside the shutter button.*

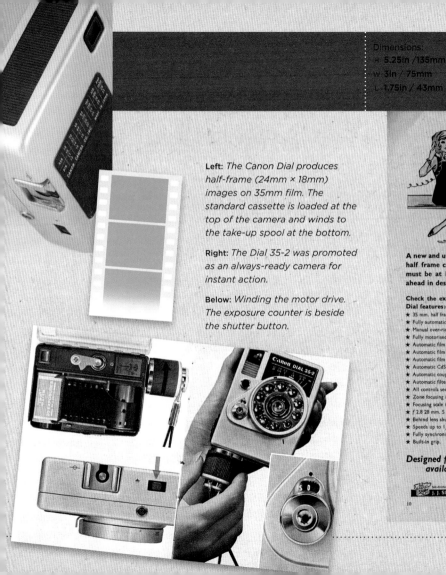

Chapter 4
1970–1979

The 1970s saw massive changes in camera technology, particularly in the second half of the decade. Early automatic-exposure SLRs—the Nikkormat EL of 1972 and the Canon EF of 1973, for example—exhausted their batteries quickly and became unpopular. Dramatically smaller and lighter SLRs became popular after the advent of the Olympus OM-1 in 1974 and the revolutionary OM-2 in 1975, and Canon's extensive use of plastics and microprocessor control in the Canon AE-1 of 1976 and introduction of multi-mode electronic control in the Canon A-1 of 1978 totally changed preferences in the SLR market. The new Kodak 110 film cartridge and format, introduced in 1972, rapidly gained popularity—again, because of its size, making possible truly pocket-sized cameras, as the larger film formats faded from the domestic market.

Dzerzhinsky
FED 3 1972

The Fed 3, manufactured in the Soviet Union between 1962 and 1980, was one of a long series of Fed cameras that made direct and poor copies of the Leica II from 1934 until the 1990s. The EOS was a coupled-rangefinder 35mm camera with interchangeable 39mm screw-mount (Leica mount) lenses and an approximation of Leica rangefinder coupling.

The FED name commemorated Felix Edmundovich Dzerzhinsky, who had the dubious honor of being the founder of the Soviet Secret Police and had a labor commune in Kharkov named after him where the original FED cameras were made. The Russians were not alone in imitating German 35mm camera designs. Canon and Nikon were both inspired in the same way.

The Fed 3, shown here, has a film-advance lever (as opposed to a wind-on knob), a flat top, and no-strap lugs. These place it as made in 1972, as do its documentation and the hand-etched birthday greeting from November 7th on the back. It came with its original box and manual, all in Russian, and the Ukranian weather-proof leather case that's nearly as solid as the camera. Interesting graphics and imagery from the instruction manual give us a glimpse into the mindset of the USSR 40 years ago. I can't imagine that the residents of the labor commune had a very colorful, artistic existence, however.

The FED 3 is more reliable than the earlier FEDs, as by the 1960s they were being made by trained staff in proper factory conditions, and were much more reliable than contemporary Zorki cameras.

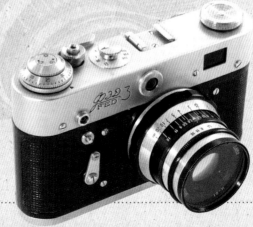

Dimensions:	Country:	Lens:
H 3.55in / 90mm	**Russia**	52mm *f*/2.8–*f*/16
W 5.5in / 140mm		Film:
L 3.15in / 80mm		**35mm**

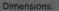

Above: *Detailed instructions show how to set the film-type reminder dial and the exposure counter.*

Above Right: *Each camera was supplied with a quality assurance certificate.*

Left: *From behind, you can see the viewfinder eyepiece (left), the shutter release, and lever-wind assembly. The collar around the shutter button has to be rotated to "B" to rewind the film.*

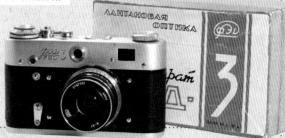

Canon
CANODATE E 1973

The Canodate E was first marketed in 1971, and coming out of the box with a rose-tinted instruction manual and a typeface that was probably only ever seen on futuristic 1970s television shows, this camera actually pioneered the data-imprint feature that was taken for granted by the 1990s. The camera design was a development of the successful Canonet series that, a decade earlier, had caused a stir among Canon's rivals for being a mid-class camera from a high-end producer that was very afforably priced. The camera pictured here is the later version of the Canodate from 1973.

The Canodate had appealing features, such as a small orange light on the top that blinked when the shutter button was half-way depressed, giving ample warning to the person being photographed to prepare themselves. The viewfinder gave the photographer a heads-up on such details as battery life, flash readiness, camera shake warning, and date imprinting information. The date indicator on this sample went from the actual year of its manufacture, 1973, all the way forward to 2009 (a 36-year lifespan) and the month settings had numbers and Roman numerals. As well as printing the date details on the film negative within the printed area, the year was also printed along the top of the film. Oddly, the Canon logo, although on the printed instruction manual, is nowhere to be seen on the camera itself, despite the logo being unchanged since its redesign in 1956.

Upon its release in 1971, the Canodate cost about £31 (approx. $75.92) in the UK—a little less than the average weekly wage of £38.10s.4d (approx. $94.33).

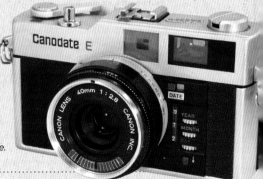

The year, month, and day for date imprinting were set using the dials on the front of the camera. The Canodate was the originator of the "databack" principle.

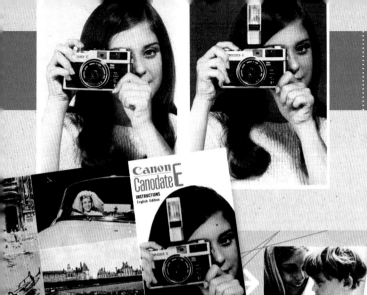

Dimensions:	Country:	Lens:
H 3.15in / 80mm	Japan	40mm 1:2.8
W 5.1in / 130mm		Film:
L 2.6in / 65mm		35mm

Left and Below: *Full instructions on EE photography (electronic exposure), were given because programmed shutters were still little understood. Users were even instructed on the direction in which to press the shutter button.*

Above: *The instruction book gave full advice on the use of electronic flash.*

Right: *On the top of the camera was an early example of a "hot shoe," making it unnecessary to use a synchronization cable to connect the camera to the flash.*

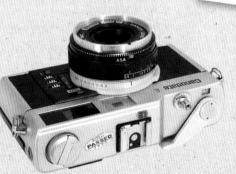

Mamiya
MSX 500 1974

The Mamiya MSX 500 was a high-quality 35mm SLR with, unusually, TTL spot metering rather than averaging exposure measurement. It was, in fact, a slightly simplified "budget" version of the 1974 Mamiya DSX 1000, which had switchable averaging or spot metering, a top shutter speed of 1/1000 second, and built-in delay action. These features were absent from the MSX 500 to reduce its price.

Set up in 1940 by engineer Sechi Mamiya with financial backing from businessman Tsunejiro Sugawara, Mamiya spent the war years manufacturing its first unique design, the coupled-rangefinder Mamiya-6 folding camera, the world's first roll-film camera that was focused by moving the focal plane rather than the lens. In 1945, its facilities were destroyed in the Allied fire-bombing raids on Tokyo, and Mamiya had to rebuild and re-equip to continue. By 1946, it had begun manufacturing its own shutters and Sekor lenses.

On top of that, because of Allied restrictions once hostilities had ceased, no Japanese camera companies were allowed to sell to their home market before proving that it was a serious camera exporter. Somewhat ironically, the largest purchasers of Mamiya cameras initially were Allied forces personnel. Throughout the years, Mamiya has maintained a superb reputation for making professional-end medium-format cameras, but despite its amateur range being equally well-engineered, it failed to get the sales it desired.

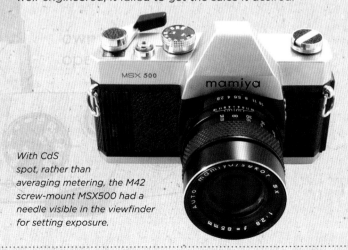

With CdS spot, rather than averaging metering, the M42 screw-mount MSX500 had a needle visible in the viewfinder for setting exposure.

DESCRIPTION OF PARTS

Dimensions:	Country:	Lens:
H 3.75in / 95mm	Japan	85mm f/2.8–f/18
W 5.9in / 150mm		Film:
L 4.3in / 110mm		35mm

Accessory Shoe model 2: The Magnifier: Angle Finder:

15. Film chamber
16. Viewfinder eyepiece
17. Focal plane shutter
18. Film advance sprockets
19. Film take-up spool
20. Film compartment door
21. Film pressure plate
22. Film cartridge pressure plate
23. Battery compartment cover
24. Tripod socket
25. Rewind release button

Above: *The instruction book was very detailed and provided pictures of useful viewfinder and close-up accessories available.*

Left: *The MSX 500 had an early example of the plastic-tipped wind lever and an uncluttered top plate.*

Right: *This was also an early example of a ribbed grip to improve handling. Oddly for a 1970s SLR, it had no flash horseshoe, though clip-on ones could be obtained.*

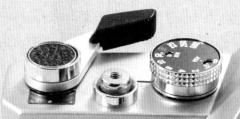

Keystone
EVERFLASH 30 1974

The amazing camera that never needs flash cubes. Makes its own flashes!

■ Instant loading ■ Uses Kodak 126 film ■ f/5.6 3-element coated lens ■ Made in US

Pre-empting the time when all our gadgets would rely on rechargeable batteries (think of all modern cameras or phones today) this 1970s camera is one of the first that powered up from the mains, its unique selling point being that it would never require external flashcubes.

An interestingly packaged camera (it came in a brass-hinged presentation box), the Everflash series was made by Berkey Photo, who were, at one time, one of the largest photographic companies in the world, third behind Kodak and Polaroid, with annual sales in excess of $200 million. It is probably best remembered for having a dispute with Kodak after introducing the Everflash in direct competition with the hugely successful Kodak Instamatic, using the same 126 film cartridge. It captured about 15% of the instant-loading market. On June 25th 1973, *Time* magazine reported on a pending lawsuit brought by Berkey Photo Inc. who charged Kodak with "attempting to monopolize." Appeal and counter-appeal came and went and although an initial award of over $100 million had been made in favor of Berkey, after much wrangling it received $15.25 million. This was not enough to prop up the ailing photo division, which was sold off in 1978.

The sample shown here was produced in 1974 in the USA.

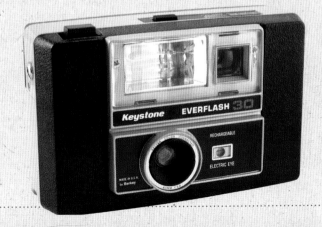

Right: *The Everflash 30 with inbuilt rechargeable battery and electonic flash predicted the demise of flashbulbs and flashcubes.*

Keystone Everflash 30
■ Lifetime Rechargeable Battery
■ Electric Eye
■ Built-in electronic flash

MADE IN USA BY BERKEY

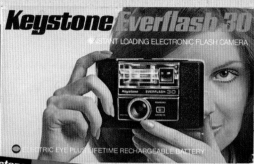

Keystone Everflash 30
INSTANT LOADING ELECTRONIC FLASH CAMERA

ELECTRIC EYE PLUS LIFETIME RECHARGEABLE BATTERY

Dimensions:	Country:	Lens:
H **3.15in / 80mm**	**USA**	**Keytar 40mm f/5.6**
W **5.1in / 130mm**		Film:
L **2.4in / 60mm**		**126**

Keystone
INSTANT-LOADING ELECTRONIC FLASH CAMERA

30-40 INSTRUCTION BOOKLET

Above: *The instruction book concentrated heavily on the "computer" flash capabilities of the camera.*

Below: *Simplicity was the appeal—"Load, Aim, Shoot."*

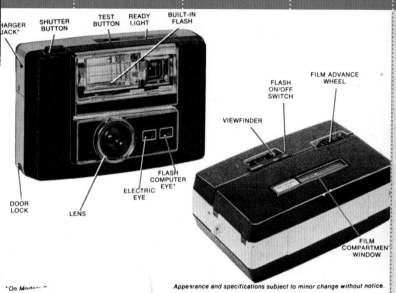

CHARGER JACK* SHUTTER BUTTON TEST BUTTON READY LIGHT BUILT-IN FLASH

FLASH ON/OFF SWITCH FILM ADVANCE WHEEL

VIEWFINDER

DOOR LOCK LENS ELECTRIC EYE FLASH COMPUTER EYE*

FILM COMPARTMENT WINDOW

* On Models

Appearance and specifications subject to minor change without notice.

Above: *Exhaustive explanation for such a simple, automatic camera.*

SHORT FORM INSTRUCTIONS – Read entire booklet for details.

LOAD

AIM

SHOOT

1. Attend to the battery – non rechargeable models, see page 6; re- ...

2. Frame the subject in the viewfinder composing the desired scene.

3. Holding the camera steady, slowly press the shutter button.

Canon
AE-1 1976

Every now and then there is a truly epochal moment in photography, a moment in which there is a seismic shift. Back in 1974, Canon pulled together a development team of engineers who were charged with delivery of a long-time ambition of the company—a fully automatic SLR camera. Over the next two years it drew on a wealth of technology and expertise to invent a new kind of camera and become the dominant SLR manufacturer in the world. In April 1976, the launch of the AE-1, followed in 1978 by the announcement of the multi-mode Canon A-1, put Canon at the head of in the amateur SLR market. It was a strong position to finally secure leadership with the announcement of the Canon EOS 650 and the first Canon EF autofocus lenses in 1987.

Canon neatly combined a well-thought-out product, compactly manufactured in new, lightweight materials, with a vast array of features revolving around a Central Processing Unit—never before seen in an SLR. It also embarked on an unprecedented advertising campaign that brought about sales of over five million during the AE-1's eight year production run. The AE-1 was also the first in the hugely successful line of A-series cameras that culminated in the A1 in 1978. The strategy that Canon adopted was to target the vast amateur market as opposed to slugging it out with the likes of Nikon for supremacy in the professional arena. The average joe embraced the concept of having an easy to use, intelligent, beautifully designed camera.

Released in 1976, the AE-1 was priced at around £190 (approx. $345.45) when the average weekly wage was just under £85 (approx. $154).

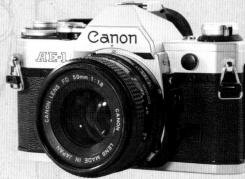

Dramatically smaller and lighter than earlier Canon SLRs, the AE-1 also offered shutter-priority automatic exposure or manual operation.

CANON "A" SERIES

Dimensions:	Country:	Lens:
H **3.55in / 90mm**	**Japan**	**50mm 1:1.8**
W **5.5in / 140mm**		**f/1.8-f/22**
L **3.15in / 80mm**		Film:
		35mm

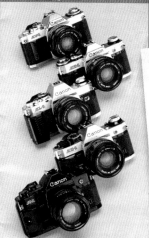

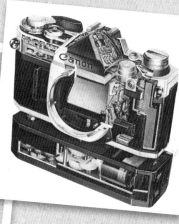

Shutter Button Lock

Above: *Illustration from* The Canon SLR, *by L. Gaunt, 1978, Focal Press.*

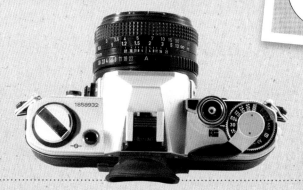

Left: *A new range of bayonet-fitting rather than breechlock FD lenses was announced with the AE1. Note the "A" for automatic setting on the 50mm f/1.8 lens on the camera.*

Above: *Detailed diagrams showed the complex electronics of the AE1, plus how the autowinder fitted the camera, the shutter speed dial, the auto/manual switch, and the shutter button lock.*

Rollei
POCKETLINE 300 1977

According to the double-page advert in 1976's *British Journal of Photography* annual, Rollei "had been creating the right image since 1921" and summarized its mission as "Helping you get the best out of photography—whether you earn your living from it or simply enjoy it as a leisure pursuit. Now don't you think it's time you improved your image?"

There can be no doubting Rollei's huge impact on the photographic world in the 56 years before the release of the Pocketline 300, so it's possible it was still smarting from its previous foray into 110 cameras with the excellent A110 camera that was criticized for being too expensive at $300, when it bought out this cheaper model. Considering Rollei's long pedigree, this wasn't

its best, but did reflect the fad for the 110 film format, which gave "worry free" loading for the uninitiated snap-shooter, as it was impossible to load the cassette the wrong way round and still shut the camera back. It was light, small, and flat, making it ideal as a pocket camera, and this version had its own electronic flash rather than the flash-cube bar that slotted into the top. It had telephoto and normal lens settings with advice in the instructions that warned of "your subject appearing larger in your picture" when set to "tele."

I just love the 1970s man on the box lid with obligatory 'tache. Apparently, we all had them back then. Ahem.

Released in 1977 and bought in by Rollei from a manufacturer in Japan, the Pocketline cameras were not products of Rollei's Singapore factory.

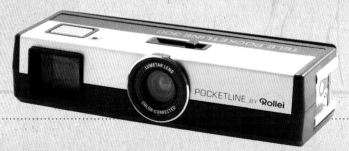

Slim, pocketable and effective, the Pocketline 300 was the top of a range of three cameras. A separate electronic flash unit fitted to the end of the camera.

Dimensions:	Country:	Lens:
H **1.1in / 28mm**	**Japan**	**Lumetar 24.5–34mm *f*/11**
W **4.5in / 115mm**		Film:
L **1.7in / 42mm**		**110**

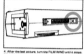

LOADING FILM

TAKING FLASH PICTURES

Above: *Detailed instruction diagrams illustrated how to load the camera, fit the flash unit, and insert batteries.*

Right: *R.F. Hunter were the UK importers for Rollei products in the 1970s.*

Above: *Pocketline cameras were sold as complete outfits—traditionally Kodak's style rather than Rollei's.*

Below: *This top view shows the large rectangular shutter button above the viewfinder.*

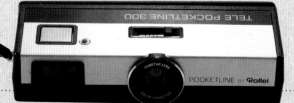

Agfa
OPTIMA SENSOR 335 1978

This neat, stylish, attractive little camera is simple to use and fits easily into the hand or pocket. Lightweight thanks to its plastic construction, the Optima Sensor 335 was quite sophisticated for a compact camera. Historically, the Optima Sensor range of viewfinder cameras, released in the late 1960s, was credited with being the first to boast automatic shutter exposure. It had a lens with three-zone focusing, as illustrated by the icons around the edge, and the automatic exposure was driven by a light-metering cell, found at the bottom of the lens.

Clever design features included the switch on the top, which, when moved to its R position, which enabled the film to be rewound by using the normal winder arm (which, unusually, also housed the firing button), a frame counter inset into the side of the camera body, and a user-friendly little battery compartment on the inside. Also, when the back of the camera was opened, a small hatch popped open to give easy access to the film cassette. The big, bright viewfinder has a luminous frame indicating the limits of the image area, making it easy to sight with either left or right eye. Just in case you weren't sure of which button to press to take a picture, the Optima, conveniently, came with a big red one. All in all, a smart little product that was made in Germany and released in 1978.

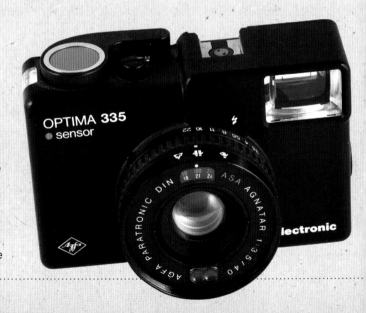

Dimensions:	Country:	Lens:
H 2.75in / 70mm	**Germany**	**Agnatar 1:3.5/40**
W 3.9in / 100mm		**f/3.5–f/22**
L 2.2in / 55mm		Film:
		35mm

Above: *The Brightline viewfinder had parallax adjustment lines for framing subjects close to the camera.*

Left: *The Agfa Optima Sensor 335 was one of a series of seven Optima Sensor cameras, including one with coupled rangefinder and one with built-in flash.*

Right: *Detailed "how to" pictures showed how to open, load, and set the film speed on the camera.*

Below: *Square, neat lines made this an eminently handleable camera.*

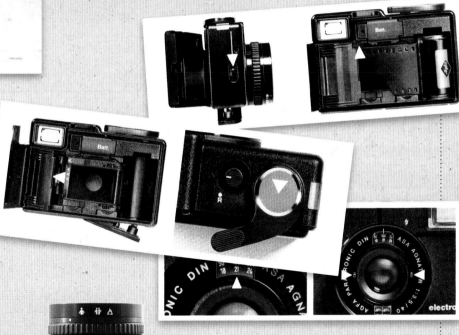

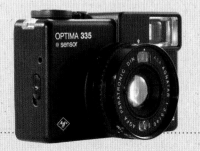

Above: *Film speeds can be set in ASA/ISO or in the DIN system, used mainly in Germany.*

Left: *The top view shows the diagramatic focusing settings and the hot shoe for flash.*

Olympus
TRIP 35 1978

OLYMPUS TRIP 35
with D ZUIKO F2.8 f= 40mm

Though the model shown here was released in 1978, the Trip—so named for its targeted holiday market—was introduced way back in 1967 and had a production run of almost 20 years. Called Takachiho Seisakushu ("Plains in the high Heavens") and considered a bit of a tongue-twister outside its native Japan, the company was renamed Olympus in 1921.

Popularized by David Bailey (the photographer who famously shot portraits of London gangsters the Kray Twins, Andy Warhol, The Beatles, and other iconic 1960s celebrities) in a TV advertising campaign ("Who's he?", went the famous catchphrase), it's often reported that it sold over 10 million units, a figure that has been queried by fans who claim that the lack of high serial numbers indicate a smaller production run. The number on this sample suggests "three million, four hundred thousand, seven hundred and sixty nine" and because it has a hidden date code under the pressure plate that confirms it as a 1978 model, it seems unlikely that it wheezed itself along to a total of ten million in the remaining five years.

All that aside, it was a really good point-and-shoot camera that used photocells to power up rather than batteries. The Zuiko lens was extremely sharp, even at the corners, out-performing rival, more expensive equipment of the time. Thanks to solid advertising that included Patrick Lichfield, Olympian Daley Thompson, and Everest mountaineer Sir Chris Bonnington, Olympus soon had 50% of the compact camera market and was brand leader in the total 35mm market in the mid-80s.

This example dates from May 1978 and was made in Japan.

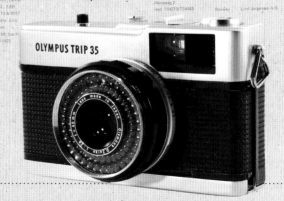

Dimensions:		Country:	Lens:
H	**2.75in / 70mm**	**Japan**	**Zuiko 40mm 1:2.8**
W	**4.5in / 115mm**		**f/2.8–f/22**
L	**2.2in / 55mm**		Film:
			35mm

5 Set ASA Film Speed

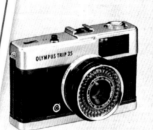

Turn ASA Setting Ring until ASA number of the film being used appears in the ASA Window.

Above: *Easy-to-follow instructions for setting the film speed.*

Right: *The film instructions provide a diagram version of the "Sunny 16" rule for estimating exposure.*

Below: *The rugged, reliable Olympus Trip had a selenium cell exposure meter with the cell behind the honeycomb window around the lens.*

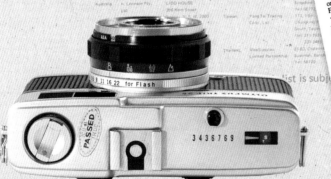

E G F S P

INSTRUCTIONS

OLYMPUS TRIP 35

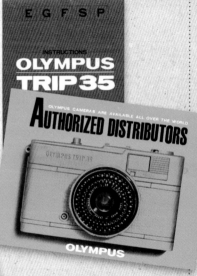

AUTHORIZED DISTRIBUTORS

OLYMPUS CAMERAS ARE AVAILABLE ALL OVER THE WORLD

OLYMPUS

Above: *Olympus had, and still has, a formidable worldwide marketing and servicing organization, and the "Authorized Distributors" guide gives details to Olympus users.*

Camera shutter speed 1/12

Bright or Hazy Sun on Light Sand or Snow F16		
Bright or Hazy Sun, Distinct Shadows F11		
Weak Hazy Sun, Faint Shadows F8		
Cloudy, Bright, No Shadows F5.6		
Cloudy, Dull, No Shadows F4		
Bright Sun, Subject in Shade F4		

Pentax
AUTO 110 1978

In more than 90 years of production, Asahi Pentax have been at the forefront of technological and design innovations in the photographic industry. The Asahi Optical Joint Stock Company, founded in the Toshima suburb of Tokyo in 1919, quickly became a leading supplier of lenses to Japanese camera and optical manufacturers, with binoculars, rangefinders, and aerial cameras offered as part of its repertoire.

In 1945, it began research into SLR cameras, pioneering vital developments and introducing the world's first SLR with an instant-return mirror (the Asahiflex IIB) in 1954, and its first Pentax models with pentaprism viewfinder in 1957—this was the point at which Pentax had arrived as a big player. The 110 camera seen here was the smallest interchangeable lens SLR with through-the-lens metering ever made. The body and three lenses could easily be held in the palm of your hand and Pentax gave a choice of six lenses, two flash units, and a motor drive. The black-bodied version was the most common, but Pentax also produced a Safari version in a tan color and even a

transparent version showing all the internal circuitry and workings, specifically made for dealer displays. Despite its resemblance to a toy water pistol it was very successful and upgraded to the Super version in 1982 with minor advancements. Highly desirable red boxed sets were released packed with the whole system, complete with lenses, drives, and even filters.

This camera was released in 1978 at the same time as another Japanese company were making waves with a miniaturized product—the portable music player called the Sony Walkman.

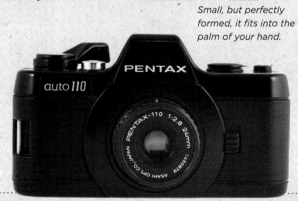

Small, but perfectly formed, it fits into the palm of your hand.

HOLDING THE CAMERA

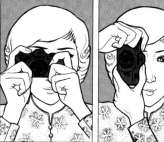

1. Horizontal position

2. Vertical position
(shutter release button on top)

3. Vertical positi...
(shutter release button...)

Dimensions:	Country:	Lens:
H **2.2in / 55mm**	**Japan**	1:2.8 24mm
W **3.75in / 95mm**		Film:
L **2in / 50mm**		**110**

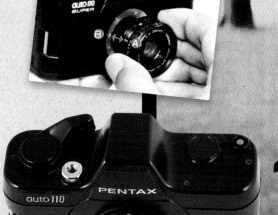

Below: *The camera has a bright viewfinder with a split image focusing screen with a microprism ring.*

Above: *For such a small camera, the instructions were exhaustive. The method of holding the camera was important to avoiding camera shake and blurred pictures.*

Right: *A range of five interchangeable lenses plus two flash units were available for the Pentax A110.*

Below: *Control layouts do not come any simpler than the top plate of the Pentax A110.*

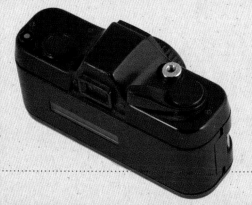

Nikon
EM 35 1979

Nikon introduced the EM as a rival to the hugely successful Canon AE-1 and the OM-10 from Olympus. In a departure from its usual workman-like, solid, hefty products, this was its first model in a range of new designs that established a compact, lightweight, easy-to-use camera that still retained the engineering quality of previous Nikon bodies. The EM had a metal skeleton encased in polycarbonate that made it extremely rugged, but light, which was a radical development away from the anchor-like weight of the earlier Nikkormats, and more.

Stylish and elegant, the EM made picture taking easy, with only automatic aperture priority (you set the *f*-stop and the camera does the rest), and included a feature that we take for granted on modern SLRs—the audio "beep" warning if aperture settings are deemed not safe (when camera shake is just around the corner). Also, although it was a battery-dependent electronic camera, it had a mechanical mode, just in case power failed.

It seemed that even the heavyweight-camera producers were waking up to the old Kodak concept of "You press the button, we do the rest." Nikon fans needed to realize that there was nothing wrong with having simpler, uncomplicated cameras—all its rivals had been doing the same for a while—and the company knew the importance of appealing to both amateurs and professionals as Canon had done so successfully.

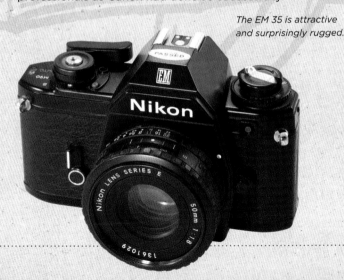

The EM 35 is attractive and surprisingly rugged.

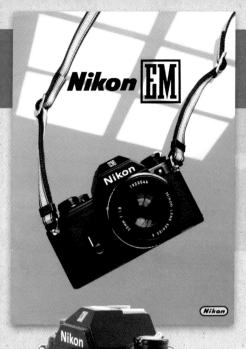

Dimensions:	Country:	Lens:
H **3.4in / 85mm**	**Japan**	**50mm 1:1.8**
W **5.1in / 130mm**		**f/1.8–f/22**
L **3.55in / 90mm**		Film:
		35mm

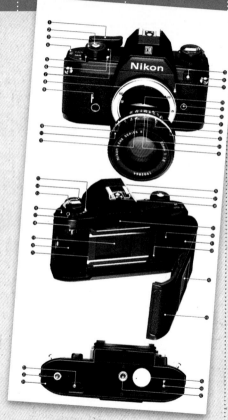

Above Left and Above: *The instruction manual and documentation is detailed. The Nikon EM was sold with a new 50mm f/1.8 Series E lens, and other budget-priced "E" lenses were added to the range with it.*

Right: *Exact descriptions of features are typically Nikon. The EM can be fitted with almost any Nikon "F" mount lens, but needs Nikon AiS lenses, or "E" lenses for full automatic exposure to operate.*

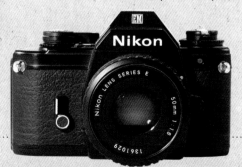

139

Pentax
ME SUPER 1979

The 1970s had ushered in a dramatic and rapid change in who was bossing who in the global camera-manufacturing race, and Japan had become the leading producer. Japanese firms were even scrapping amongst themselves. Olympus, having produced its first full-frame 35mm SLR, the FTL in 1971 threw down the gauntlet by decreasing the size and weight of its SLRs by almost 25% when it introduced the OM-1 in 1974 and the OM-2 in 1975. Canon waded in and caught everyone by surprise in 1976 with its AE-1, and then Pentax stepped into the dojo in the same year with the even-smaller and lighter Pentax ME. Canon then announced the multi-mode Canon A-1 in 1978.

The Pentax ME Super of 1979 really did represent state-of-the-art of Japanese technology and ingenuity, with touches like a bright viewfinder with a split image microprism ring in the center (a glossy sales brochure shows the focusing effect with images of a dancing girl), a small window next to the wind-on lever illustrating movement of the film, which greatly helped avoid that annoying moment when the film was rewound all the way back into the film cassette, and an endearing feature to Pentax fans—the ability of the camera to continue operating with a fixed shutter speed of 1/125 second even after battery failure. As suggested by the caressing red fingernails in the brochure, it was a highly desirable object—presumably more so for men.

Released in 1979, the same year cell phones were invented, the Pentax ME Super went on to win various industry awards.

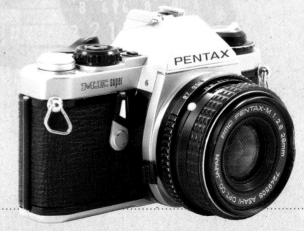

Dimensions:	Country:	Lens:
H **3.25in / 82mm**	**Japan**	**Pentax-M 1:2.8**
W **5.1in / 130mm**		**28mm *f*/2.8–*f*/22**
L **3.15in / 80mm**		Film:
		35mm

PENTAX® 35mm **INTERCHANGEABLE LENSES**

Above Left: *Just what you need to put the focusing screen through its paces—a dancing girl.*

Above: *The shutter speed set by the camera is indicated by a colored light beside a scale on the left-hand side of the viewfinder, shown above.*

Left: *The Pentax ME Super had shutter speeds from 4 seconds to 1/2000 second and the choice of Aperture Priority automatic exposure or manual exposure setting. This example is fitted with a 28mm f/2.8 Pentax M-series wide-angle lens.*

Above: *A large range of Pentax K bayonet mount M-series lenses were available, plus many accessories, including flash units.*

Right: *The ME Super is a compact, light, and multi-capable camera.*

f/4

5 4 3 2 1 0

Distance (m)

Chapter 5

1980–1999

This period saw further diversity in the field of camera capabilities, with Kodak releasing yet another film format to replace 35mm, Polaroid making a talking camera, Canon rising to its position as market leader with more technical innovations and even a camera that looked like Darth Vader! People power ensured a revival of LOMO's fortunes leading up to the Millennium, as its funky, retro-style cameras enjoyed an increase in popularity.

'PAY ATTENTION... THIS IS A SLIDE!'

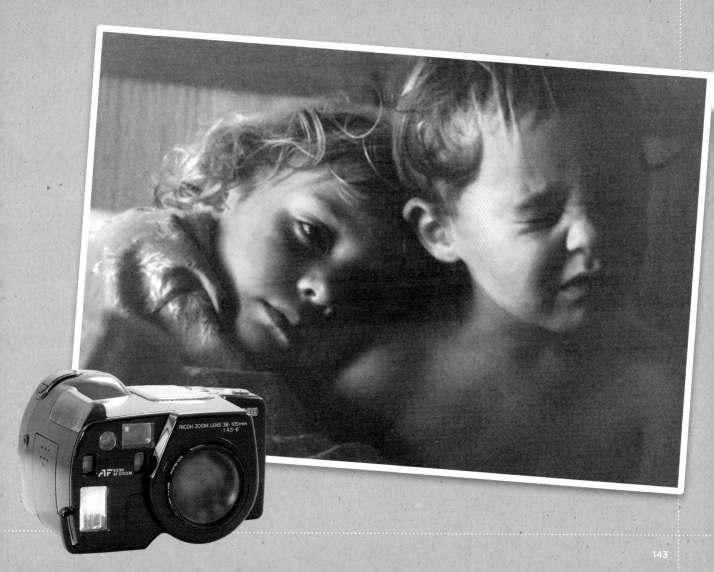

LOMO
LUBITEL 166B 1980

The original Lubitel range (Lubitel translates as "amateur") went into production back in 1949 and was manufactured in Russia in Saint Petersburg when the city was known as Leningrad, in the State Optical-Mechanical Factory (abbreviated as GOMZ in Russian). The "2" version superseded the original in 1955 and 21 years and two million units later, in 1976 the 166 model began to roll off the production line. By this time the company name had changed to the more familiar "LOMO."

A twin-lens reflex camera, the Lubitel 166B was mass-produced in plastic with no frills. This solid, reliable medium-format camera produced 6 × 6cm images from 120 roll film. Framing the subject matter could be a little confusing as the image in the viewfinder appeared back-to-front. This example appeared in 1980 (according to the documentation). Despite the vast numbers of Lubitel cameras produced over a 50-year period (estimated at between four and five million), what was a cheap, knockabout product will doubtless rise in value because of the collectability of LOMO cameras.

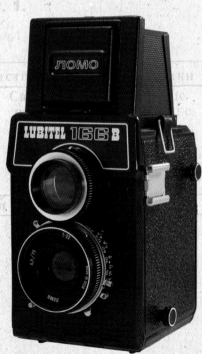

The Lubitel 166B has an f/4.5 lens, shutter speeds from 1/15 to 1/250, and focuses from infinity to a little over a metre. It is a fully mechanical camera with no built-in metering.

Dimensions:	Country:	Lens:
H **6.7in / 170mm**	**Russia**	**75mm _f_/4.5–_f_/22**
W **3.55in / 90mm**		Film:
L **3.9in / 100mm**		**120**

Below: _Each Lubitel 166B came with its own quality-assurance certificate._

Below: _Seen from above, the gearing that couples the lenses for focusing is clearly visible._

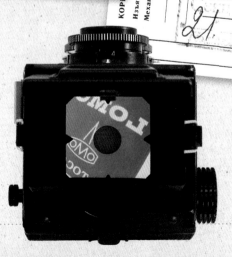

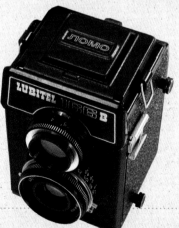

Left: _The viewfinder focusing screen, as seen by the photographer, has a flip-up magnifier for precise focusing._

Canon
AF35ML 1981

Thanks to the increasingly rapid advances in electronics at the beginning of the 1980s, the Canon was one of many first-generation autofocus products, but it differed from a lot of its competitors because it could produce excellent results, thanks to good lens technology, and often found its way into the professional photographer's kit bag as a reliable back-up to their main camera.

Originally, Konica, a rival company, had marketed the world's first AF camera back in 1977 using Honeywell's Visitronic system, but Canon wanted to improve on its less-than-perfect performance in low light. Mysteriously, having manufactured the earlier version of this camera with an excellent infra-red focusing system of its own design that could literally focus in the dark, this updated model from Canon had a different Solid State Triangulation (SST) autofocus system. Still, that quirk aside, this camera majored on everything "auto"— focusing, exposure, film loading, film advance, power rewind, and built-in flash, and because of its superb

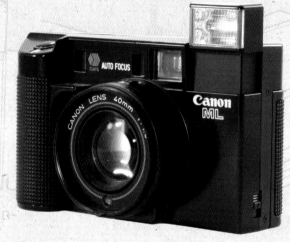

A full-frame 35mm camera (24mm × 36mm), the Canon AF35ML had an electromagnetic programmed shutter providing speeds from 14 seconds to 1/400 second.

40mm *f*/1.9 Canon lens, when most competitor cameras had *f*/2.8 lenses, the AF35ML produced top-quality images.

The sample shown here was produced in Taiwan in 1981.

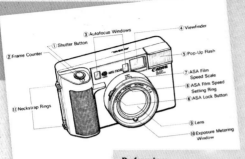

Figure labels:
③ Autofocus Windows
④ Viewfinder
① Shutter Button
② Frame Counter
⑦ Pop-Up Flash
⑦ ASA Film Speed Scale
⑧ ASA Film Speed Setting Ring
⑥ ASA Lock Button
⑪ Neckstrap Rings
⑤ Lens
⑩ Exposure Metering Window

Dimensions:	Country:	Lens:
H 2.75in / 70mm	Taiwan	Canon 40mm 1:1.9
W 4.7in / 120mm		Film:
L 2.2in / 55mm		35mm

Prefocusing

When you wish to compose the picture so that your subject is not in the center of the

do not change the shooting distance.
3. Press the shutter button all the way down

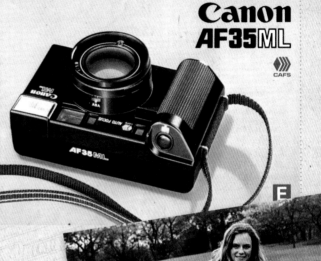

Canon
AF35ML

Above: *Canon instruction books are generally excellent and this one goes into great detail.*

Right: *The cover of the instruction book shows the pop-up flash retracted into its "idle" position.*

Below: *The back of the AF35ML is smooth and uncluttered, and the superb 40mm f/1.9 Canon lens produces bitingly sharp results.*

The AF35ML is great for quickly-taken family shots.

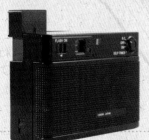

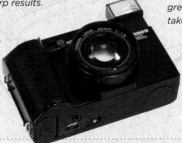

Kodak
DISC 4000 1982

It was almost as if a century's innovative photographic development had been squashed flat by the introduction of this ultra-thin offering. Technically brilliant and a marvel of industrial design apart from one fairly major detail—the size of the film—the disc system was introduced in 1982 with a much-trumpeted revolutionary revolving circular disc of 15 8 × 10mm color negatives.

This thin, flat disc, enclosed in an equally thin plastic housing, then had a camera designed around it. The film, thicker than modern 35mm film, was more comparable in thickness to 5 × 4in sheet film, but of course, the negatives were tiny and disappointing when printed up, especially as a lot of photographic printing companies hadn't invested in Kodak's special six-element enlarger lenses, preferring to stick with its standard three-element ones instead. The camera was sleek, easy to load and use, had a built-in flash, and was less prone to camera shake than the 110 standard cameras due to the exposure button on the front.

In April 1997 Kodak websites began to inform consumers that the film was being withdrawn (more than 10 years after the cameras had stopped being made), and by the way, the new APS system was much better.

This sample was made in 1982 in the USA and cost $68 dollars. Such was the influence of Kodak on the photographic world that, despite its shortcomings, the Disc camera still sold more than 25 million units in its five-year production run. Kerching!

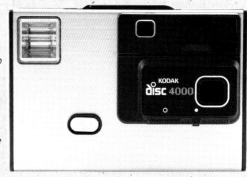

Fitted with a 12.5mm f/2.8 lens and built-in flash, the unloved Disc 4000 was a fixed-focus failure in most people's eyes, particularly the millions of people that bought them.

THE DISC CAMERA

Dimensions:	Country:	Lens:
H **3.15in / 80mm**	**USA**	**Glass f/2.8**
W **4.7in / 120mm**		Film:
L **1in / 25mm**		**Disc**

Minimize shake by holding a Disc camera with your thumbs behind it and fingers on the front.

The easy-loading disc cartri... permits the camera body to ... remarkably slim. The film d... revolves inside the cartridg... presenting new areas for exposure.

Above and Far Right: *The Kodak instruction book was attractive on the outside, and informative on the inside.*

Right: *Detail from the Kodak booklet* The Photographer's Notebook.

Kodak disc cameras should have been successful, but the trade disliked them, the results were poor, and soon everybody disliked them.

ADVANTAGES AND DISADVANTAGES

● Slimmer than the 110, a Disc even fits a shirt pocket.

...era shake is less likely ...h Disc than a 110 — the ...lease is on the front of ...

...cartridges give a flatter ...h 110 cartridges, and so ...r guarantee of overall ...ness.

...cs are simple, even fool-

proof to operate, giving a high success rate if used in the conditions specified. On some models the flash goes off automatically if there's not enough light.

● As with the 110, enlargements larger than postcard size may be disappointing.

● With 15 frames a disc, these cameras are more expensive to run than 110s.

9

Left: *Rear of camera showing disc insertion.*

Right: *Illustration from* The Story of Kodak, *by D. Collins, 1990, H. Abrams Inc.*

149

Canon
T80 1985

Canon's four T-series cameras (okay, there were actually five, but the T60 came as an afterthought years later) were brought to market in quick succession over three years, starting in 1983 with the T50 and ending with the T90 in 1986. The 80 was its first 35mm SLR autofocus camera. Replacing the successful, but ageing A-series cameras with the Ts spanned the phase prior to introducing the new EOS system in 1987 (see pages 162–163).

There was a palpable feeling within the industry that, because of the global economic downturn and a general technophobia, the consumer wanted less expensive, easier-to-use cameras. Looking more like a grenade launcher than a camera, the T80 only stayed in production for a year and is therefore quite rare, as are the three lenses made for it, the 50mm, 35–70mm zoom (shown here), and the 75–200mm.

The bragging rights about features had to be played down so as not to overload the consumer with too much confusing data. Canon was one of the pioneers of LCD display panels, but it's ironic that intelligent cameras were seen as too clever for the bulk of its intended customers. Unlike its major rivals, Minolta and Nikon, Canon was of the opinion that having a focusing motor in the lens rather than the camera body was the right way to go. And all this time later it seems it was absolutely spot on.

This model, made in Japan, was released in 1985.

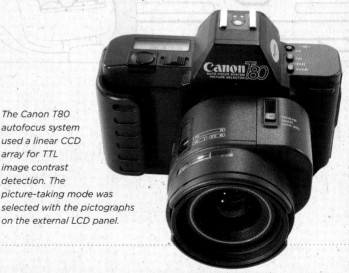

The Canon T80 autofocus system used a linear CCD array for TTL image contrast detection. The picture-taking mode was selected with the pictographs on the external LCD panel.

Dimensions:	Country:	Lens:
H 4in / 100mm	Japan	35–70mm Zoom
W 5.5in / 140mm		Film:
L 4.5in / 130mm		35mm

1980–1999

Above: *The T80 instruction book was informative and easy to follow.*

Right: *The autofocus was slow by modern standards, but was still effective, even for moving subjects.*

Below: *The autofocus zoom lenses could be switched to manual focus if desired.*

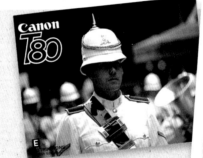

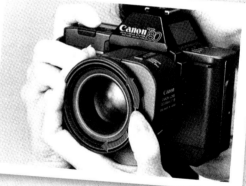

Above: *Manual focusing of the zoom lenses was easy. You could also fit Canon FD bayonet-mount lenses and focus those manually if you wished.*

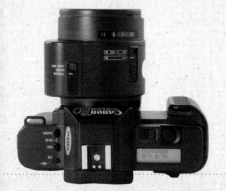

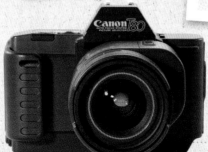

Ricoh
MIRAI 105 1988

A bit of a howler in the looks department compared to modern-style cameras, this curiosity was unearthed in a sleepy charity shop one rainy morning. Knowing just a little about Ricoh's more stylish heritage (particularly its mid-century products), I was surprised by this bug-ugly piece, but then again, it was produced in the 1980s, when the TV show *Miami Vice* was at its peak...

Ricoh has a history going back to 1936. Today, the company specializes in digital imaging and photography and has multi-billion dollar revenues, owning Pentax, IKON, and the IBM printing division, among others. The Mirai (Japanese for "the future") was designed for one-handed use, according to the instruction manual, with a side handgrip (removed for these photographs) much like modern video cameras. Similar in size to early box cameras, it was compact and crammed with the usual electronics that included an LCD screen, integral flash, auto-zoom, remote control, macro photography feature, and even fill-in flash. Awkward, unbalanced, and probably unloved, it was the only Mirai SLR camera in a

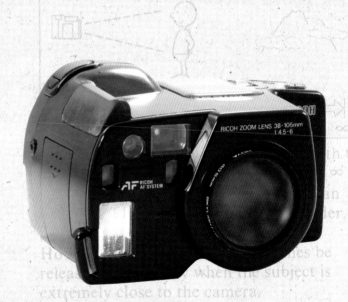

The Rico Mirai 105 has an electronic shutter with speeds from 1 second to 1/500 second and a 38mm–105mm f/4.5 zoom lens.

small series. It was produced as a joint venture with Olympus and released in 1988.

MIRAI 105 EFSG

Owner's Manual
Manual de instrucciones
Mode d'emploi
Bedienungsanleitung

RICOH

Dimensions:	Country:	Lens:
H **3.15in / 80mm**	**Japan**	**Ricoh Zoom 38–105mm 1:4.5–6**
W **5.1in / 130mm**		
L **3.9in / 100mm**		Film: **35mm**

Above: *Like most Ricoh instruction books this one was plain and functional, but effective.*

Right: *Diagrams illustrate clearly the instructions given.*

Below: *With the camera on its back, the LCD screen is plainly visible.*

[E] Taking Photographs

Use the Combination strap. (See p. 105)

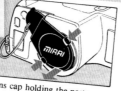

Remove the lens cap holding the parts marked.

While looking through the viewfinder, aim the camera at the subject.

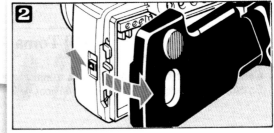

To open the back, slide the camera back release knob.

Above: *The back catch of the camera (referred to in the diagram above) is clearly visible at the left-hand end of the camera.*

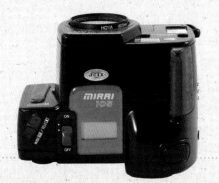

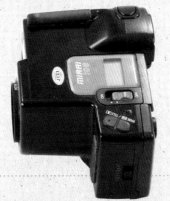

Konica
AIBORG 35-105 ZOOM 1991

The history of Konica goes back to 1873—the same year that Agfa opened its doors, and before Kodak was in operation. It is yet another Japanese company with its origins based in Tokyo. Konica are notable for releasing the Cherry, a name that would have a lot of resonance in Japanese society, in which the spring-time blossoms (Sakura) are very significant. This was the first Japanese camera to have a brand name.

Despite the name, there is nothing flowery about this product that Konica described as "futuristic, black, ellipsoidal." It certainly is, but its key descriptor could be Vader-like, right down to the rubberized piping and array of buttons on the back (even the LCD display has a *Star Wars* feel to it)—you almost expect it to start breathing heavily. The artificial intelligence is in large supply here as the camera is fully automatic, with a broad range of capabilities that include auto focus, macro and zoom shooting, integral flash, two-mode self timer, night mode, multi exposure, and even a TV mode for shooting images from the television without banding—all clever stuff.

The bird emblem on the top of the camera, contrary to what you might expect, has no historical significance. Having a closer look at the 90-page manual , it turns out that it marks a self-timer indicator—a Japanese version of "watch the birdie," perhaps.

Released in 1991, this model is a capable piece of camera technology from a respected manufacturer—albeit wrapped up in a comical looking body.

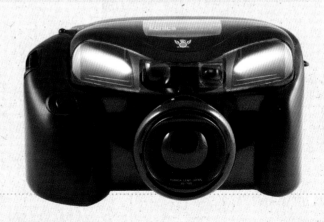

PRECAUTIONS FOR USE

Dimensions:	Country:	Lens:
H **3.55in / 90mm**	**Japan**	**35-105 Zoom**
W **5.5in / 140mm**		Film:
L **3.15in / 80mm**		**35mm**

Above and Right: *You need to be the sort of person who understands diagrams to use this instruction book.*

Left and Below: *The Aiborg looks more practical and less surreal from above, with the flash unit on the right of the picture and the LCD screen in the middle.*

Above: *The LCD screen and function buttons—using these requires a lot of memorizing.*

Below: *Guidance on the zoom range of the 35mm–105mm zoom lens.*

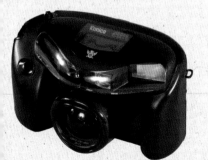

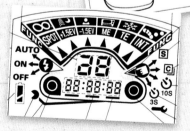

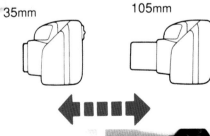

35mm

105mm

1980-1999

LOMO
SMENA 8M 1992

Though the Lomo Smena was made up until 1993, it was introduced in 1970. In total contrast to its distant relative from the early 1960s, the Smena 8M was Hong Kong-made, and very flimsy, bending nicely if you squeeze it hard enough between forefinger and thumb. It would probably pass as a cheap kids' toy, but had one saving grace—the lens.

The lens enabled the camera to shoot in the fashionable LOMO style with vibrant color and contrast, with the desirable fall-off at the edges when the lens is wide open. Sharp images are possible when the lens is stopped all the way down to f/16 and the camera is cocked by setting a lever on the side of it. As with a lot of point-and-shoot cameras from earlier decades, the exposure reference is displayed as a set of weather symbols that are explained in the instruction booklet, which seems to be made from recycled paper, as does the box it comes in. According to the Lomographic

Society website, the word Smena translates as "young generation," and to quote, "True to its name, the Smena line of cameras were designed to provide inexpensive, accessible, and excellent photography tools to the hard-working young Soviets of the time."

There are conflicting ideas about its production run, but it's suggested that this model went into production in the 1970s and continued for a couple of decades. All the paperwork that came with the model shown here is stamped or hand-written as 1992, which correlates with the serial number imprinted on the base of the camera (92752998).

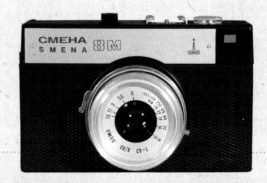

The Smena 8M had a 40mm f/4 lens in a shutter speeded 1/15 to 1/250.

Dimensions:	Country:	Lens:
H 3.15in / 80mm	**Russia**	**T-43 4/40 f/4-f/16**
W 4.5in / 115mm		Film:
L 2.5in / 62mm		**35mm**

Аппарат фотографический
«СМЕНА-8М»

Цена

ТУ2 3.046-00
Упаковщик Артикул 1С50-02018
Дата изготовления

(месяц, год)

Рис. 2

9 — кольцо с индексом и шкалой глубин резкости;

10 — шкала символов расстояний;

11 — синхронизатор;

12 — шкала диафрагм;

13 — шкала светочувствительности пленки;

14 — кольцо установки диафрагмы и светочувствительности пленки;

15 — объектив;

16 — кольцо со шкалой расстояний;

17 — шкала выдержек;

18 — штативное гнездо;

19 — окно видоискателя;

20 — шкала счетчика кадров;

21 — головка перемотки пленки;

22 — приемная катушка;

23 — задняя крышка;

24 — прижимная планка;

25 — кнопка замка.

Above: *Every Lomo came with its own authentication ticket.*

Right: *The instructions—here in Russian—go into great detail.*

Below: *With the camera on its back, it is possible to see the focusing symbols, the accessory shoe, the rewind knob and the shutter button.*

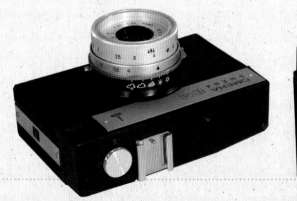

Left: *The shutter cocking lever can be seen at 10 o'clock to the lens.*

Polaroid
636 TALKING CAMERA 1995

The 600 series were bulk standard, low-end instant cameras, mostly with cheap plastic lenses that did not give particularly good results, especially indoors. What you got was an autofocus camera with a setting for close-up work. The flash could be switched off with the "non-flash" button for close-ups, so you didn't completely blast out the subject with light, and when you moved the slider over (for subjects between 2ft and 4ft away from the camera), a piece of plastic slid in front of the viewer to give you a framing guide.

Polaroid used its patented Sonar Autofocus in the earlier square-edged models, but these later round-cornered models had the switchable autofocus system. Ingeniously, the camera is powered by a battery in the film-pack insert. So, with the absence of the film, it can't be fired up and checked.

This camera came with three pre-recorded messages, one of which said something along the lines of "When I say cheddar, you shout cheese," and you could even pre-record your own personalized message—imagine all the

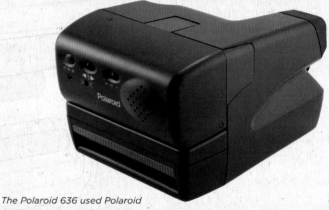

The Polaroid 636 used Polaroid 600 series integral film, had a fixed focus lens, and automatic flash. When not in use, the camera is closed up.

fun teenagers had with that feature! According to the instructions, "It plays amusing messages just before the shutter opens, generating spontaneous smiles from your subjects at just the right time." (I'll bet it did.)

This entertaining product was made in the USA and released in 1995.

Dimensions:
H **5.9in / 150mm**
W **4.7in / 120mm**
L **5.7in / 145mm**

Country:
USA

Lens:
Unknown

Film:
Polaroid 600 integral film

1980–1999

Left: *The instruction booklet (and the sound effects) came in several languages.*

Below: *Excellent diagrams illustrated instructions for loading and using the camera.*

1　　　　2　　　　3a　　　　3b　　　　4

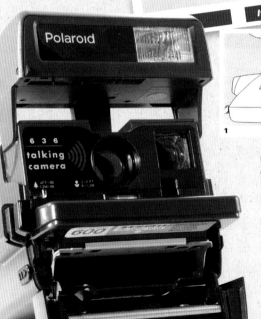

Left: *When opened up fully, the portal where the film pack was placed is visible.*

Kodak
ADVANTIX T700 WEATHERPROOF APS 1998

An ultra-compact camera measuring 2.4in (h) × 3.55in (w) × 1.2in (l), the Advantix was packed with technology and based around the short lived Advanced Photo System, APS (1996 to 2004). As the camera's name suggests, it was weatherproof, with rubberized grips and seals enabling the user to take pictures in damp conditions—for example on the beach, on skiing trips, or in Seattle.

Geared to the snap-shooter, the T700 was awash with features such as double-exposure protection and a flip-up flash that reduced red-eye. And the benefits of the APS system included three sorts of picture format—HDTV, Panoramic, and Classic. You could have a Night View mode for shooting in the dark, Continuous Motor Drive, and Mid-roll Change, where the film cassette could be removed half-way through a roll (of 40 frames, by the way) and then replaced at a later date, continuing from where it left off. The photographer could even choose proofs of prints to be received from the lab before they even took the photo, and date/time ID could be printed on the back of the photo in a choice of 12 languages. APS was a really serious attempt by Kodak to upgrade photo technology away from the 35mm format that had been around for so long, a format that was soon to be blitzed by the onslaught of modern digital solutions.

Made in China in 1998, this model sold for $189.00.

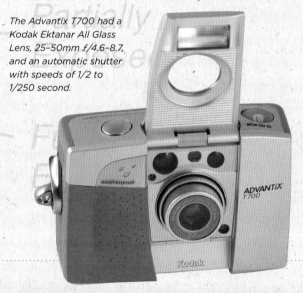

The Advantix T700 had a Kodak Ektanar All Glass Lens, 25–50mm f/4.6–8.7, and an automatic shutter with speeds of 1/2 to 1/250 second.

Dimensions:	Country:	Lens:
H **2.4in / 60mm**	**USA**	**Zoom lens 25–50mm**
W **3.55in / 90mm**		Film:
L **1.2in / 30mm**		**APS**

1980–1999

Left: *Kodak marketed an extended range of color negative films in its elliptical "Kodak Film Safe cassette," and processed film was returned in the cassette with the prints and an index print. Fuji also made APS film.*

Right: *Shooting data was displayed on an effective LCD screen.*

Below: *Controls and the LCD screen were on the back of the camera.*

Left: *Cassettes were loaded and unloaded through a door in the base of the camera.*

Canon
EOS 3 1998

EYE CONTROL

For me, the Canon EOS 3 epitomizes how far technology has come since the start of the twentieth century. The eye-controlled auto-focus was jaw-dropping—you just looked at the required point of focus on the focusing screen and the camera focused on it. Canon started its EOS project in 1985 (Eos was the Greek goddess of dawn; more prosaically, it has been suggested that EOS was simply an acronym for Electronic Optical System), with the aim of designing a next-generation SLR system that would keep the company ahead of the game.

In a mere two years Canon had come up with brand new systems, lenses, and accessories, and had launched the EOS 650 in 1987, the world's first commercially successful autofocus system with the autofocus system within the lens. A huge success, the EOS system grew, with new models and new features available almost every year. Eye-controlled focusing appeared first in the EOS 5 of 1993, and was further developed for the EOS 3, launched in November 1998, which had a mind-boggling

45 focusing points and was the world's first autofocus SLR with an area AF system.

On the outside, this camera was all ergonomic curves and rugged strength, and inside, at the heart of its awesome technology, was Eye Control. The photographer calibrated their eye to the viewfinder and the system would then know what was being looked at and focus accordingly. Auto Focus lenses later became even more sophisticated with the introduction of image stabilization systems.

The EOS 3 was released in November 1998.

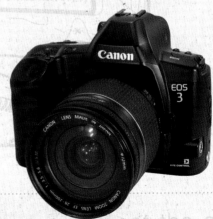

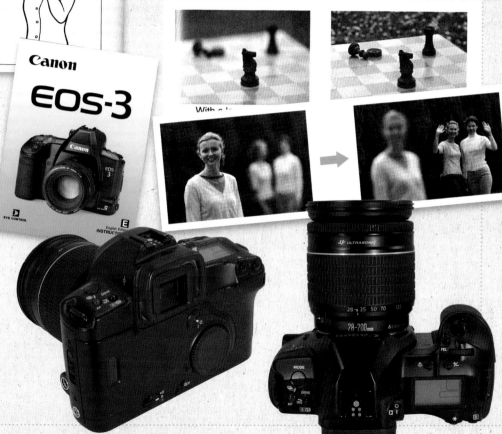

- To maintain a stable stance, place one foot in front of the other instead of lining up both feet.

Dimensions:	Country:	Lens:
H **4.7in / 120mm**	**Japan**	**Zoom 28–200mm AF**
W **6.3in / 160mm**		Film:
L **6.1in / 155mm**		**35mm**

Canon

EOS-3

EOS 3

EYE CONTROL

English Edition E
INSTRUCTIONS

Left: *A Canon EOS 3 with Canon 28–90mm EF zoom lens. The EOS 3 incorporated the world's first area AF system, with higher speed eye-control compared to the earlier EOS 5 and improved high-speed focus tracking. In the early EOS camera models the number of autofocusing points went from one to three to five before making the hyper-jump to 45 in the EOS 3.*

Above: *The usual excellent Canon instruction book uses diagrams extensively.*

Right: *The EOS 3, like the Pro EOS 1 and 1n models, had the large knob on the back to set modes on the LCD screen.*

Top Right: *The instruction book explains depth of field control in some detail.*

With a l

LOMO
LC-A 35MM 1999

It is rather apt that we should conclude the selection for the twentieth century with a camera that is the epitome of a basic, simple product raised to the dizzy heights of success by hype and marketing. The original LOMO Compact-Automat ended its production run in 1994, having been introduced ten years earlier, in 1984.

The official reason for its decline was that fewer and fewer Russians could afford a camera in the early 1990s, but an unreliable build quality (apart from the lens) must have helped to speed its demise. Enter salvation in the form of student marketeers, the Lomographic Society, and folklore. Legend has it that students from Vienna discovered the LC-A in Prague in the early 1990s, and over the next few years, boosted its popularity by promoting "Lomography" as a new youth culture. The factory had stopped manufacturing the camera in 1994, but a campaign by the Society gained such momentum, and aided by the weight of one

Vladimir Putin, the then vice-Mayor of Saint Petersburg, the decision was made to restart production in 1997.

Later, the Lomographic Society would manage to get the rights to mass produce the camera in China when production finally did stop in Russia in 2005.

As with all the camera manufacturers producing in the twentieth century, LOMO made a funky camera for the people—for a profit.

This item was manufactured in 1999 in Russia.

The LCA is manually focused by zone and has automatic exposure, but exposure can be set manually by setting the aperture with a fixed shutter speed of 1/60.

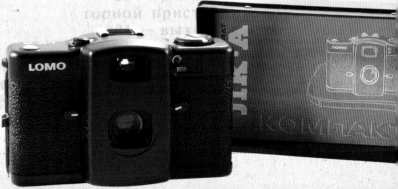

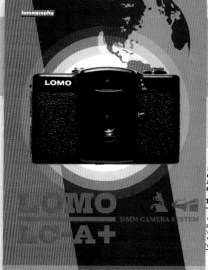

Dimensions:	Country:	Lens:
H **2.75in / 70mm**	**Russia**	**Minitar 32mm 1:2.8**
W **4.1in / 105mm**		Film:
L **1.7in / 42mm**		**35mm**

В фотоаппарате шкала чисел свето-
чувствительности имеет обозначения 25,
50, 100, 200, 400 ед. ГОСТ/ISO. Если число
светочувствительности фотопленки, заря-
женной в фотоаппарат, на шкале отсутст-
вует, установите число светочувствитель-

Таблица 1

Обозна-чения на шкале чи-сел свето-чувстви-тельности	Числа светочувстви-тельности реальных фотопленок	
	ГОСТ/ISO, ASA, ISO	ГОСТ (старый)
25	20—25—32	
50	40—50—64	22—32
100	80—100—125	45—65
200	160—200—250	90—130
400	320—400—500	180—250
		350—500

Рис. 10

Above: *The LCA+, made in China, does not have the manual exposure option.*

Above Right: *Exposure guidance card shows relationship between Western ASA film speeds and the Russian Gost system.*

Below: *When closed, the LCA's door protects the lens from damage.*

Right: *The film is wound with the serrated knob at the right-hand end, which changes the number in the exposure counter. The back of the camera is smooth and uncluttered.*

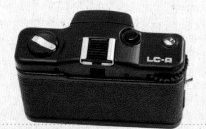

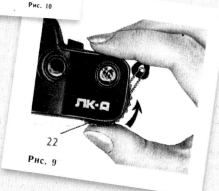

22

Рис. 9

Chapter 6

2000+

What next, then? With the rise and rise of mobile-phone cameras, resulting in plunging sales of dull looking compacts, can cult movements such as LOMO really slow the colossus that is digital photography?

The next phase of photography will depend on the next phase of photographers, on their preferences, on what's in fashion and—in these economically tough times—on what they want to spend their money on. Rewind to 100 years ago and we can see that the driving force behind the phenomenon of "photography for the masses" was based on an overwhelming desire for people to make their own images, simply and cheaply. And that's where we are now with digital systems—we can capture our moments and view them instantly. The huge difference is that we don't need stand-alone cameras any more—we can use other everyday devices to get our pictures.

Truly, more than a century after George Eastman's "You press the button" philosophy, point-and-press has cemented itself into our consciousness, both at an amateur and professional level.

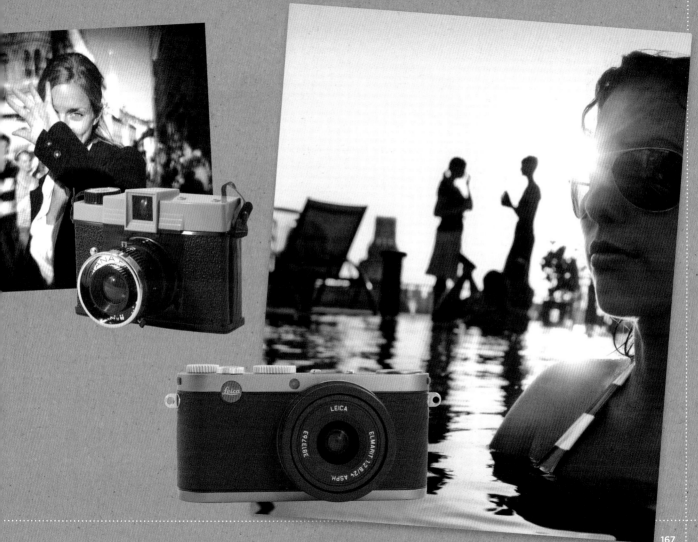

LOMO
DIANA F+ 2007

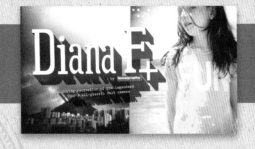

As romantic an idea as it is, and as exciting as the LOMO concept has been, will the fad for shooting on film be sidelined as a quaint, expensive art form? LOMO is not standing still and has introduced the Lubitel 166+, a development of the 1980 Lubitel (see pages 144–145) with dual-format capability (35mm or 120) and is also bringing out a video camera. The Diana cameras are comparatively cheap. I paid £30 (approx. $45) for the new "loving recreation of the legendary 1960s all-plastic cult camera" (as stated on the box), but the cost of films, processing and printing is not. The LOMOs have definitely succeeded with the help of the "fun" concept (is that what the F stands for?) and clever marketing.

This camera comes complete with 120 film, an interesting book with images from its now-famous annual "wall" of photographs submitted by enthusiastic fans who form the basis of the vibrant LOMO youth cult—and a very

heavy reputation that surely can't all be hyperbole. The cheapness of the lens helps produce quirky, imperfect images that resound with attitude. The Diana sassily thumbs its nose at the optical perfection that every other manufacturer strives to achieve. Originally categorized as a "toy" camera, the Diana first appeared in the 1960s manufactured by Hong Kong's Great Wall Plastic Company and the original samples sell for heavy prices. LOMO made the Diana Plus in 2007 and later released this version—the F+—with flash synchronization.

The Diana is a fun, lightweight little camera—perfectly portable!

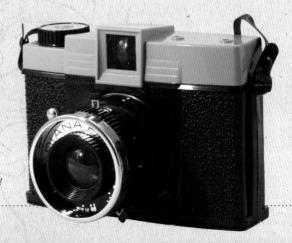

Leica
X1 2010

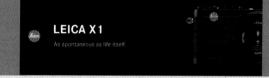

LEICA X1
As spontaneous as life itself.

It was never my intention to put a Leica in the film-camera section, purely because, first, I'm not lucky enough to own one and second, they could never really be described as cheap and cheerful. But the X1 is part of camera royalty, with a history stretching back to 1912–1913, when Oskar Barnack created his first Ur ("original" or "ancient") Leica, and with Leitz's backing, went on to produce 31 0-series pre-production Leica prototypes in 1923 and 1924, one of which recently sold for the staggering sum of £1.7 (approx. $2.7) million at auction.

The Leica X1 pays homage to the Leica cameras of the 1930s that did so much to establish 35mm still photography. Without that inventive genius, the likes of Henri Cartier-Bresson and Robert Capa—to name just a couple—would possibly never have risen to such prominence in their respective fields. All the Leica standards apply to this X1—the superb optics, the compactness, the quality engineering—as one would expect from one of the last remaining German manufacturers. And the presentation box it comes in would make Apple proud. You can tangibly feel the history humming through it, with its pop-up flash unit and the way the lens almost silently telescopes out from the body when turned on with its analog-style control dials. No convergence here—just straight stills shooting with 12.2 megapixels and a fixed 24mm lens. The ultimate in style, quality, and heritage, I doubt if many of these will be turning up in charity shops or yard sales in the near future.

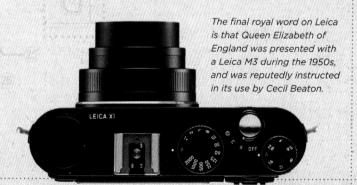

The final royal word on Leica is that Queen Elizabeth of England was presented with a Leica M3 during the 1950s, and was reputedly instructed in its use by Cecil Beaton.

Fuji
FINEPIX X100 2011

The Fujifilm company was created in 1934 and manufactured aerial cameras and photographic materials for the Japanese armed forces during the Second World War. The company first made cameras for the civilian market in 1948 when the Fujica Six I BS, a 6 × 6cm, 12–on–120 folding camera was produced, with subsequent models being produced into the early 1950s. The Finepix X100 draws on this film-camera heritage with its true retro style and stunning mid-century looks that are refreshingly different.

On a personal note, my partner, a professional photographer, couldn't believe it was a digital camera! Also, my 22-year old daughter loved it, as she'd never used a camera with a conventional viewfinder and an LCD viewer before. It's of solid construction and rammed with technology that enables you to shoot panoramas, add film effects (including black and white with or without color filters), and shoot HD movies. It has a built-in flash or the option of a hot-shoe attachment, has a macro lens option, and the software even assists the

photographer to put photo-books together. It also comes with a clever leather-look case that magnetically folds and snaps together fluidly, unlike those annoying pastones that coined the epithet "never-ready." This is a brilliant, complete package that would have been much appreciated by the Japanese artist Hokusai (1760–1849), whose famous works *36 views of Fuji* decorated the early advertisements. The X100 retails at £900.

The Fujifilm Pinepix 100 is a rangefinder digital camera with a real viewfinder and a large 12.3 megapixel APS-C CMOS sensor.

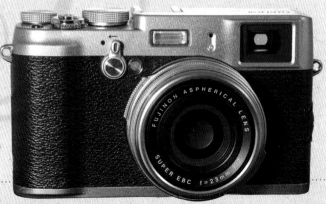

Pentax
K-01 2012

I admit it—I was seduced by the look and feel of this camera. Funky, even chunky, it felt nicely solid and well-made, with the buttons in all the right places and an extremely well-presented instruction manual with coherent visuals that didn't fill me with dread as I browsed all 265 pages of it (unlike some, which make you feel as if a PhD in nuclear science would be of great benefit). The Pentax K-01 is a compact, mirrorless digital camera with interchangeable lenses, a 16-megapixel CMOS sensor and built-in sensor-based image stabilization. Commendably, Pentax has stuck to its K-mount lenses, meaning that you can whip off your old favorites and use them on this.

Marc Newson's design is great fun and this camera has one of the simplest layouts that I've seen for a while, with excellent ergonomics. The Shake Reduction feature works with the older lenses as well—which is good if you're using a bigger telephoto, as they might take a bit of getting used to compared to the tiny, lightweight 40mm lens that the camera ships with. Image quality

is superb, with the 16.2 megapixels, and although there have been a few grizzles about the grip when using bigger lenses, that's what your other hand is for, right?

A plethora of features including auto or manual focus, pop-up flash, Shake Reduction, full HD-video shooting, a small microphone for sound recording, and even an electronic compass option. Imagine that—tourists will be able to find their way back to the bus!

Pentax are introducing some vibrant, capable cameras, very much in keeping with its excellent reputation.

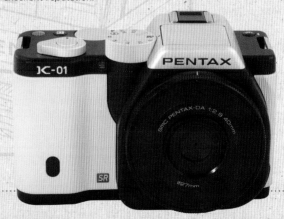

Glossary

APERTURE The opening in the lens—usually adjustable—through which light passes.

ANASTIGMAT LENS Designed by Zeiss in 1890, it was the first lens to eliminate astigmatism, which all previous lenses had been unable to do.

AUTOGRAPHIC STYLUS A metal pen-like device for scribbling information on roll films.

BAKELITE Type of plastic invented by Dr. Leo Baekeland in 1909 and used in the manufacture of cameras, radios, and so on.

BAYONET MOUNT Type of mount that used a bayonet-type attachment rather than a screw mount.

BELLOWS Concertina-type canvas extending from the camera to the lens in folding type cameras, allowing lens movement back or forwards to focus.

BRITISH JOURNAL OF PHOTOGRAPHY (BJP) The esteemed *British Journal of Photography*.

BOX CAMERA Popular box-shaped camera with a lens on the front and a viewer. As simple as it gets.

CAMERA SHAKE Movement of camera whilst taking photograph, leading to a blurred image.

CASSETTE Light-proof film container.

CDS (CADMIUM SULPHIDE) photo conductive material used in exposure meters.

COMPACT Name given to small, pocket-sized cameras, particularly from the mid 1970s and beyond.

CONSTRUCTIVISM Russian art movement in 1920s that made use of mechanical objects and structural forms.

DATABACK Prints a date and time onto the negative of the photos taken.

DEPTH OF FIELD Distance between the nearest and farthest planes in a picture. The more depth of field, the sharper the image.

DIAPHRAGM Thin overlapping metal leaves forming a circular opening in the lens.

DOUBLE EXPOSURE The accidental double exposure of 1 frame of film by forgetting to wind the film on.

ELEMENT Component of a lens which is normally a single piece of glass with two polished surfaces.

EXPOSURE The amount of light that reaches the light-sensitive film during the process of taking a photograph.

EXPOSURE METER Reads how much light is on the subject.

F-STOP Numerical expression of the lens aperture. The smaller the number, the bigger the aperture.

FALL-OFF A "dark edge" effect produced by cheap lenses or by having an inappropriate lens hood on the lens. Fall-off is a kind of accidental vignetting.

FILM IMAGE Recording material comprising a light-sensitive emulsion. Generally, sheet film for large-format cameras, roll film for medium-format, or perforated for 35mm.

FILTERS Placed in front of the lens to restrict the amount of light entering the lens or absorb colored light.

FLASHBULBS Combustible metal wire in a gas filled glass bulb, ignites and gives powerful illumination.

FLASHCUBE Cube of four self-contained bulbs that rotate when the film is wound on—normally manually.

FLASH UNIT Self contained flash unit, often powered by batteries that fix onto the camera hotshoe.

FOCAL LENGTH Distance from the lens to the image it produces. Determines the size of the image formed.

FOCUS Adjustment of the lens (by altering its focal length) to produce a sharp image.

FOLDING CAMERA Early camera design where the camera folds flat when not being used thanks to an extendable bellows system.

GRAIN Refers to the tiny metallic silver deposit on the film that "builds" the photographic image. Increases with film speed.

HALF FRAME A camera that only shoots on 50% of the normal film area. (*See* Canon Dial, Monarch Flexmaster).

HELICAL MOUNT Lens system where rotation of the lens moves some of its elements along the lens axis. (*See* Purma Special)

HOT SHOE Electrical contact on top of camera to which an electronic flash can be fitted, enabling flash to sync with shutter.

IMAGE STABILIZER Modern electronic process that reduces camera shake.

INTERCHANGEABLE LENS A lens designed to be easily attached and detached from a camera, giving the photographer more options.

LCD PANELS Liquid Crystal Display used on many cameras for top plate and viewfinder information panels.

LENS Glass optics attached to a camera body—either fixed or interchangeable—used with the camera to form an image of a scene or a subject.

MIRROR Used in SLRs and TLRs to reflect the image into the viewfinder. Drops out of the way when the shutter is depressed.

MOTOR DRIVE Battery-powered winder attached to cameras to save winding on each individual film frame.

NEGATIVE The image on film once it is processed. Once printed, it reverts back to a positive image.

PARALLAX The effect seen in cameras with separate viewers and lenses of seeing a different image to the one the camera sees.

PENTAPRISM A five–sided glass prism in SLRs which allows the image to be seen in the correct orientation.

PISTOL GRIP A grip fixed to cameras—both stills and cine—to make it easier to handle.

PLATE CAMERA Larger-format cameras that use single glass plates/sheet film.

POLARIZING Polarized light (light waves vibrating in one plane only as opposed to multi-directional normal rays) can be restricted with a filter. Reduces glare.

PRINTING The act of making an image from the film negative onto photographic paper with an enlarger.

RANGEFINDER Instrument that allows a photographer to measure the distance from the subject to the camera without moving.

SCREW MOUNT As the name suggests, a mount on a lens enabling it to be screwed into the camera body.

SELENIUM CELL Light-sensitive substance used in exposure meters. Needs no external power supply.

SHILLING Old currency used in the UK—replaced in 1971—worth the equivalent of 5p today.

SHUTTER Mechanical, normally automatic device that opens the lens to let light into the camera.

SINGLE LENS REFLEX (SLR) Type of camera where the image you view is the image you get.

SLIDE TRANSPARENCY Positive image film (usually color) in 35mm and 46mm formats. Popular as they could be viewed on hand-held viewers or slide projectors.

SPOOLED FILM Loose, not in a cassette. Required two spools, one loaded and the other for take-up.

SPOT METERING Type of exposure metering which allows you to read accurately the intensity of light from a very small area.

STANDARD 8 CINE Home-movie film format.

SUPERSLIDE 46mm film format giving bigger viewing area—popular as they fitted the same slide projectors as 35mm slides.

SYNCHRONISATION Where a flash device goes off in sync with the lens being at the correct aperture.

TRANSISTOR Early form of miniaturized electronics used in camera processing systems.

TRIPOD Three-legged stand for fixing camera to for long exposures.

THROUGH THE LENS (TTL) Exposure meter built into the camera that reads through the lens.

TWIN-LENS REFLEX A camera with a viewing lens and a taking lens. Because of a mirror-system, you do actually see what you are shooting.

VIEWFINDER System showing the field of view of the camera lens.

WINDER The lever on the camera that advances the film to its next position.

WINK LIGHT Name given to Polaroid's flash unit that was battery-powered.

Index

Acknowledgments

A two-part dedication to:

The Juniors:
Kathryn and my wonderful children Tabitha, Elliot, and baby Madelaine.

The Seniors:
David Harvey Senior and Roy Ancell for always having a camera to hand when I was growing up; Mike Ancell for the job that enabled me to buy my first camera back in 1977 (a Canon AE-1); Pat Harvey for being the most creatively inspiring person I've ever known.

A key moment in the progress of this book was the discovery of a formidable archive of *British Journal of Photography* almanacs at the premises of Old Timers Cameras in Oxfordshire, England, which made muddy history a lot clearer.

Special thanks go to all the people who have sold, loaned, and donated items to me; provided information on all sorts of historical facts and quirks; pointed me at numerous web sites that have helped to cross-reference conflicting data; and of course, the manufacturers of all these pieces.

Special thanks to: Rob Creer, Roy Ancell, and Pat Harvey for supplying archives of family photographs. Elliot Harvey for finding the time whilst studying in Tokyo to proofread and provide valuable Japanese-to-English translations. Julia Labrow and Rob Stone for aiming me at Ilex Press. The team at Ilex—Roly, Adam, James, and Tara.

For providing extra camera items: Steve Bale, Robert Butcher, Lynda and Peter Harker, and David Harvey Senior.

For last-gasp supply of digital cameras and generous help: Helen Wood at www.talkpr.com for Fuji, Jenny Hodge and Clare Lingfield at Leica (www.leica-camera.co.uk), and Steve Sanderson and Marilyn Dixon at Pentax (www.pruk. pentax.co.uk).

For valuable knowledge, expertise, and photographic paraphernalia: Ian Mulcock at Oxfam, Lynda Harker at Help the Aged, Jeff Seymour, Julie Proffitt, Caron Harrison and Pam Bass at OTC, www.otcworld.co.uk, and Petra Kellers at www.camerabooks.com.

Picture Credits: All Photography by Lawrence Harvey and Kathryn Harker.

WITH THANKS TO THE MANUFACTURERS:

Adox	Leica
Agfa	LOMO
Agilux	Mamiya
Arette	Minolta
Argus	Monarch
Balda	Nikon
Berkey Keystone	Olympus
Bolex	Pentax
Canon	Philips
Cine-Vue	Polaroid
Contessa-Nettel	Purma
Coronet	Revere
Lumière	Ricoh
Ensign	Rollei
Ensign-Houghton	Ross-Ensign
FED	Voigtländer
Fuji	Truvox
Gevaert	Weston
Halina	Yashica
Ilford	Zeiss Ikon
Kiev	Zorki
Kodak	
Konica	